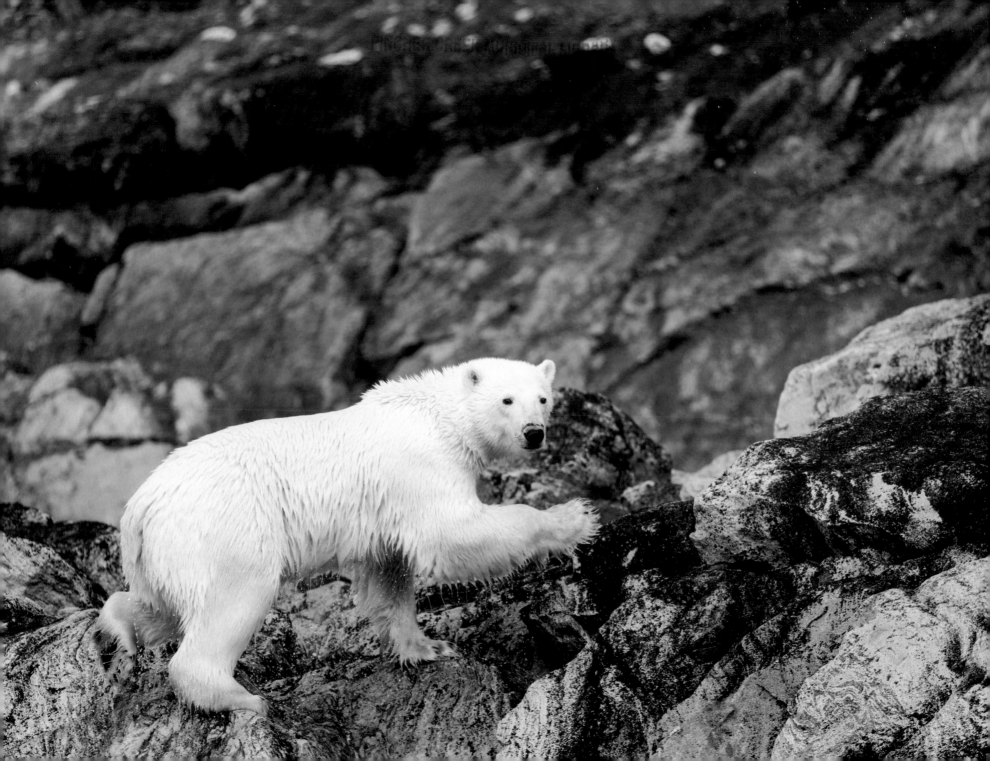

Published by Inhabit Media Inc.
www.inhabitmedia.com

Inhabit Media Inc. (Iqaluit), P.O. Box 11125, Iqaluit, Nunavut, X0A 1H0 • (Toronto), 191 Eglinton Avenue East, Suite 301, Toronto, Ontario, M4P 1K1

Editors: Neil Christopher, Kelly Ward
Art Director: Danny Christopher

Photograph locations: cover: Repulse Bay, Nunavut | page i: Repulse Bay, Nunavut | page 1: Repulse Bay, Nunavut | page 4, 5: Repulse Bay, Nunavut | page 16: Hudson Bay, Nunavut | page 17: Repulse Bay, Nunavut | page 28: Churchill, Manitoba | Page 29: Svalbard, Norway | page 40: Hudson Bay shoreline, Nunavut | page 41: Repulse Bay, Nunavut | page 58, 59: Churchill, Manitoba | page 64: Churchill, Manitoba | page 65: Hubbart Point, Manitoba | page 80: Repulse Bay, Nunavut | page 82: Hudson Bay, Nunavut, back cover: Repulse Bay, Nunavut

We acknowledge the support of the Canada Council for the Arts for our publishing program.

This project was made possible in part by the Government of Canada.

Printed in Canada

Library and Archives Canada Cataloguing in Publication

Souders, Paul, photographer
 Nanuq : life with polar bears / photographs by Paul Souders.

ISBN 978-1-77227-124-9 (bound)

 1. Polar bear–Arctic regions. 2. Polar bear–Arctic regions–Pictorial works. I. Title. II. Title: Life with polar bears.

QL737.C27S69 2016 599.786 C2016-906690-8

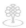

NANUQ
LIFE WITH POLAR BEARS

Photographs by Paul Souders

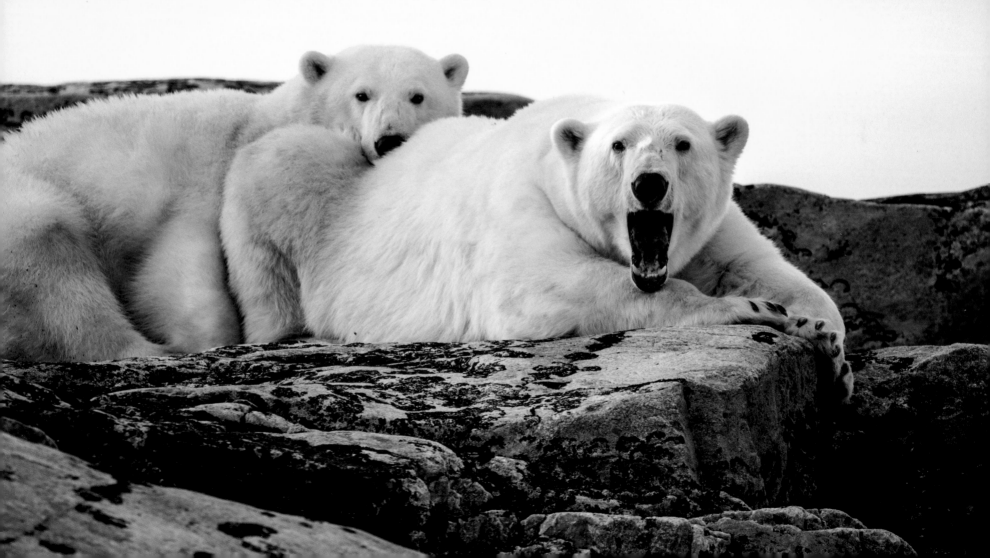

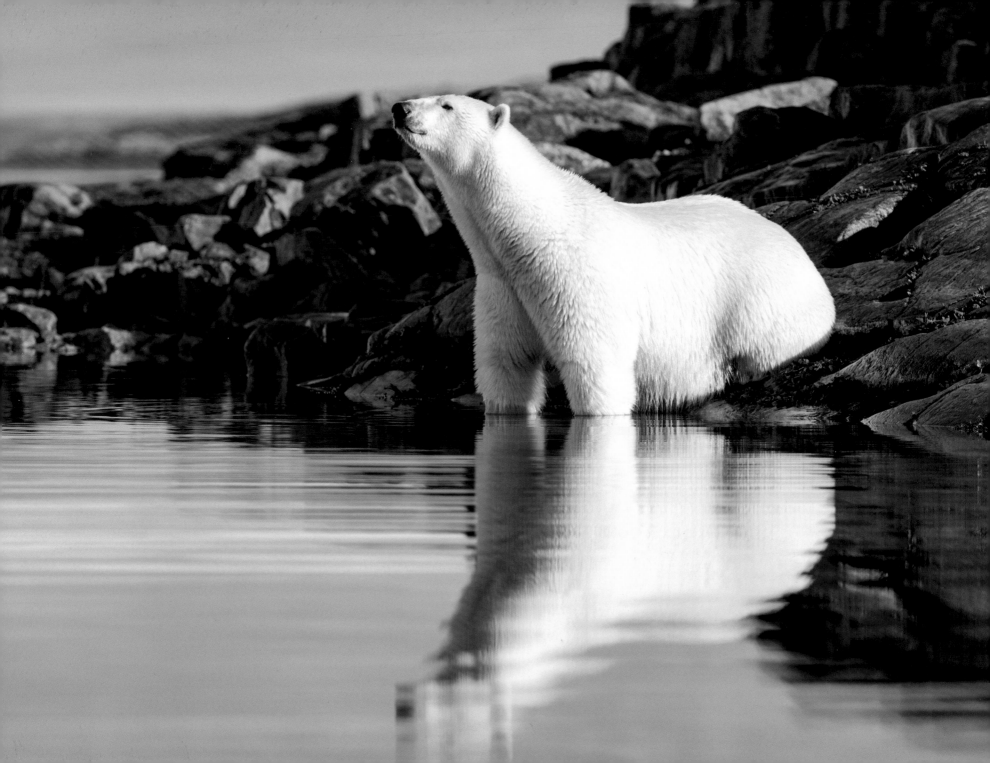

Foreword

We cohabit the Arctic with big polar bears, and we occasionally come across each other's paths. Although they are majestic and awesome mammals, we dare not go near them. They are predators that happen to eat the seals that we eat. We have so many things in common with these bears.

When I was child, we were taught early to never hope to see bears. Otherwise, we would see them up close when we least expected them. We were always taught that their behaviours are very similar to that of people. When we were in our teens, and we were stubborn with strong minds, it was said that young bears are the same.

We know and have been told that bears are not just terrestrial mammals, and that they also thrive in the sea. They are very skilled hunters, and they wait for their prey at breathing holes as Inuit do.

This book will show you polar bears through the eyes of those of us who share a landscape with these imposing predators.

—Louise Flaherty, Clyde River

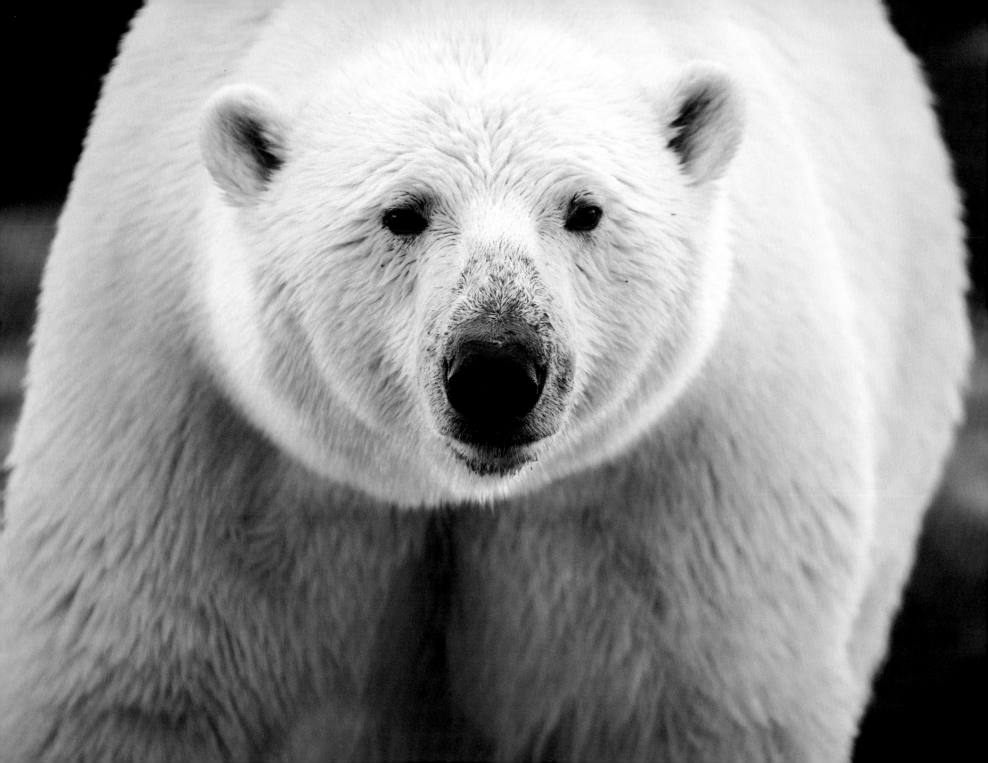

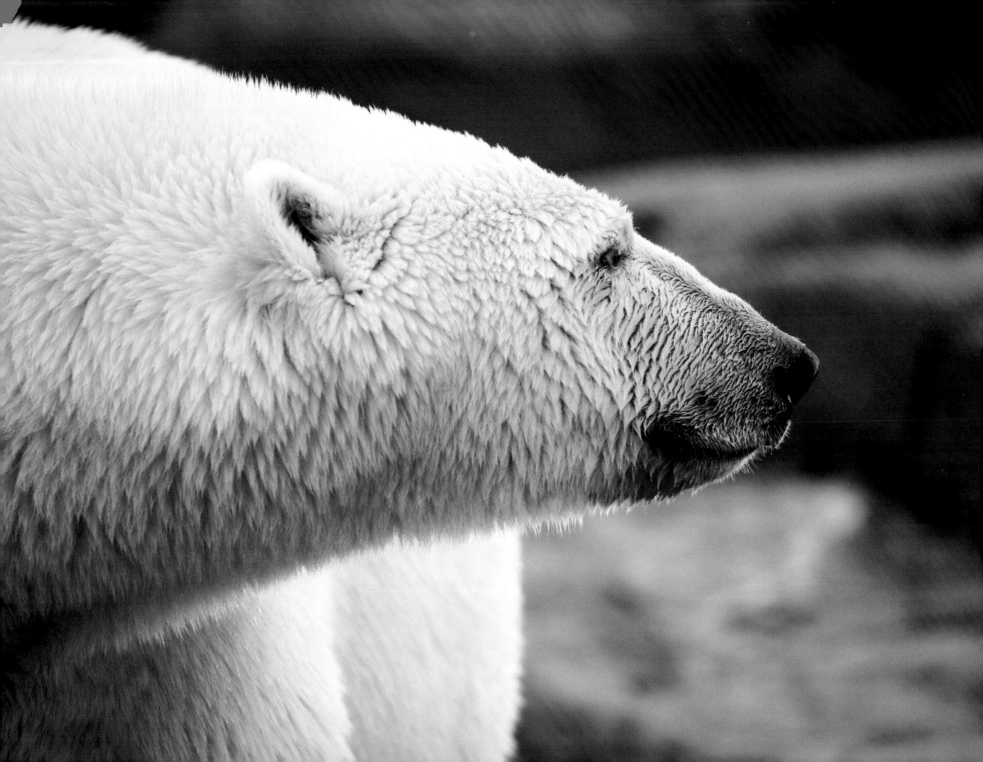

It was in early winter, when the ice had formed. I was about ten or eleven years of age. During that time, I used to set up fox traps by the shoreline, after we had harvested narwhals and belugas during the summer. We had set up some traps earlier near dead whale carcasses, and after a few days had gone by we would go back and check the traps to see if there were foxes in the traps. This time, when we got to the site where the whale carcasses were, my older partner dropped me off in the dark by the shoreline and I walked along the shore with a flashlight to check the traps. There was a polar bear very close by near the whale carcasses, and I only realized this right after my partner took off with the snowmobile. The bear made itself known by snorting and pounding on the whale meat in the dark, so I slowly backed away and flashed my partner with a flashlight. He quickly picked me up by the shoreline. I was a child, and I had no rifle at that time. The bear spared me.

— *William Flaherty, Grise Fiord*

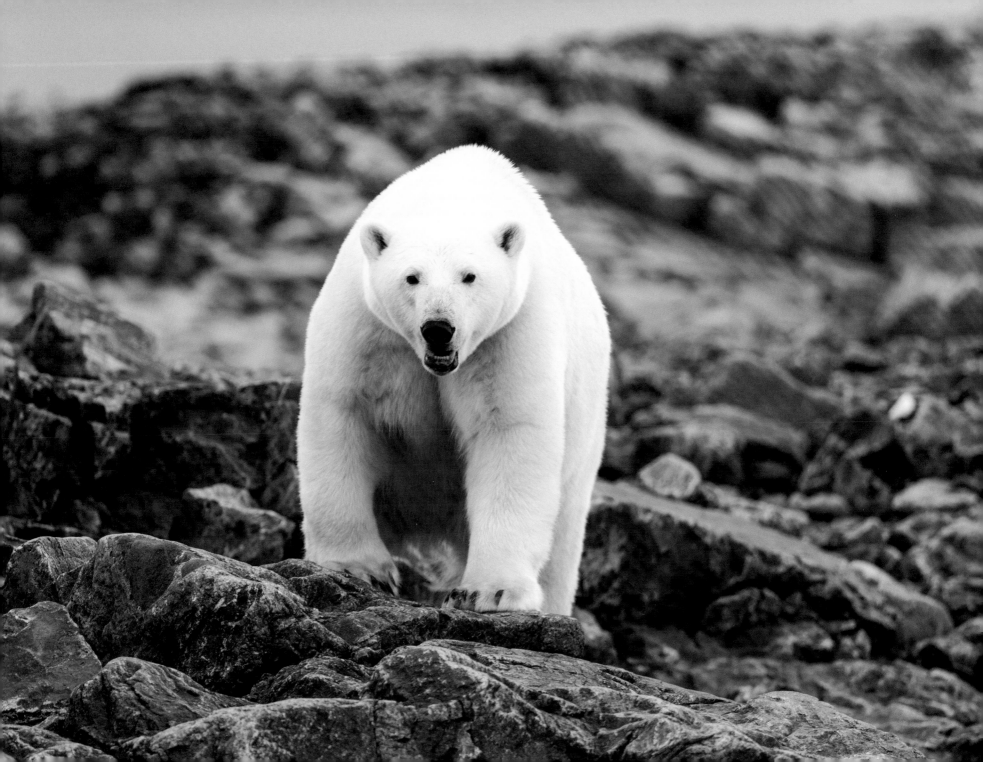

There is a saying that polar bears listen, so nobody should ever boast about not being scared of polar bears or say it is very easy to kill a bear with just a knife or say they can outrun a bear. I have heard a story about a man who wanted to kill a polar bear. He said that he wouldn't have any problems hunting for one, so he went polar bear hunting with other hunters. He kept saying all he needed to do was stab a bear with a harpoon and it would be dead, and if a bear came running toward him, he could outrun it. They made an *iglu* on the ice to camp overnight. This man slept in the middle of the other hunters. And that night, a polar bear came to their camp, broke their iglu and took the man who had been boasting with its teeth. The bear attacked him and took off. Ever since then, hunters have been told not to boast about how easy it is to kill a bear, and that bears really do listen.

—Solomon Awa, Iqaluit

Repulse Bay, Nunavut

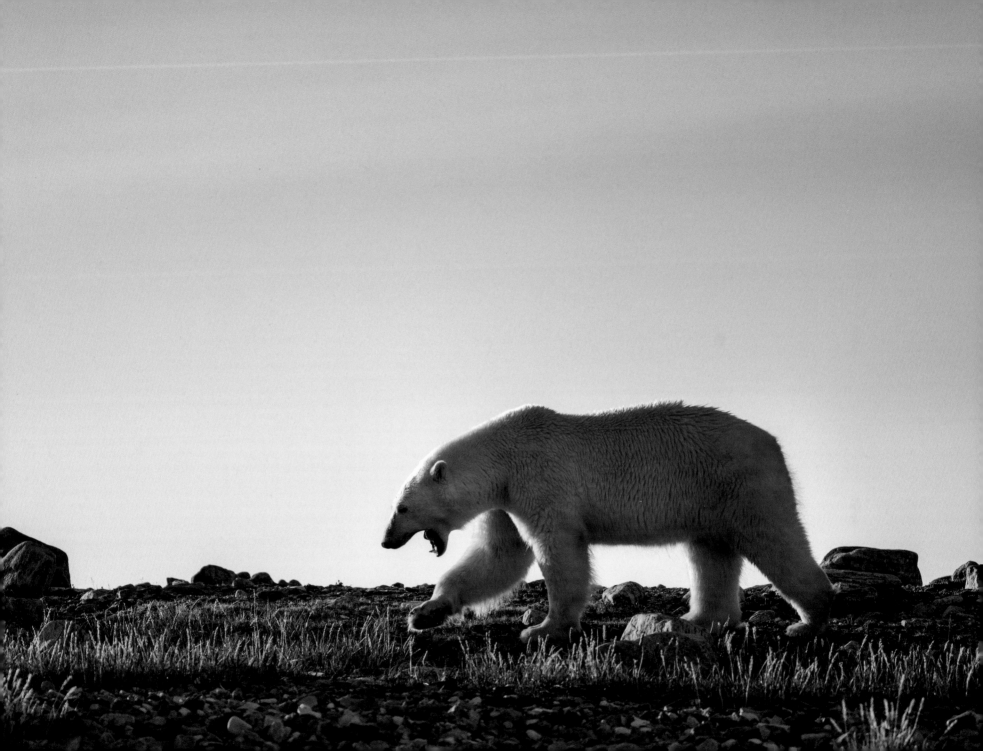

One time I was out with my brother, Donny, down at the floe edge, and we were amazed to see a huge bear. You know those huge bears; they are called *nanurluk* in Inuktitut . . . I have never seen an animal that huge. It was slowly running away. Its legs were even going deep into the snow, even though it was hard snow. It is known that they are out in the water most of the time, but this one we saw was down at the point near the floe edge.

—Darryl Baker, Arviat

Roes Welcome Sound, Nunavut

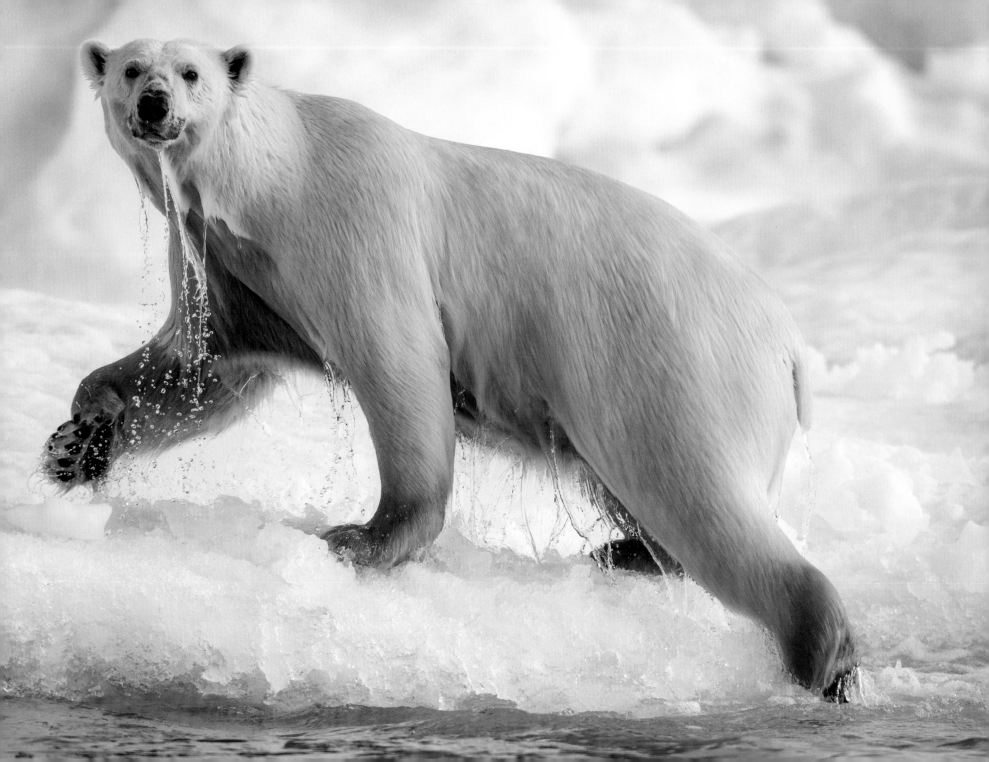

Tulaajuittut are gigantic bears that rarely go inland. They live most of their lives in the sea and on ice. Tulaajuittut are able to hunt in the sea, as they are considered seafaring mammals. Tulaajuittut eat seals and whales. Tulaajuittut are so big that they have been thought to be icebergs. Big male polar bears can grow up to thirteen feet, but they are small in comparison to a *tulaajuittuq*. It has been heard that a grown man's feet, wearing big winter boots, can fit into a single track of a tulaajuittuq with room to spare. Although tulaajuittut are very big, they are smaller than *nanurluit*. Nanurluit are said to be as big as islands.

—Louise Flaherty, Clyde River

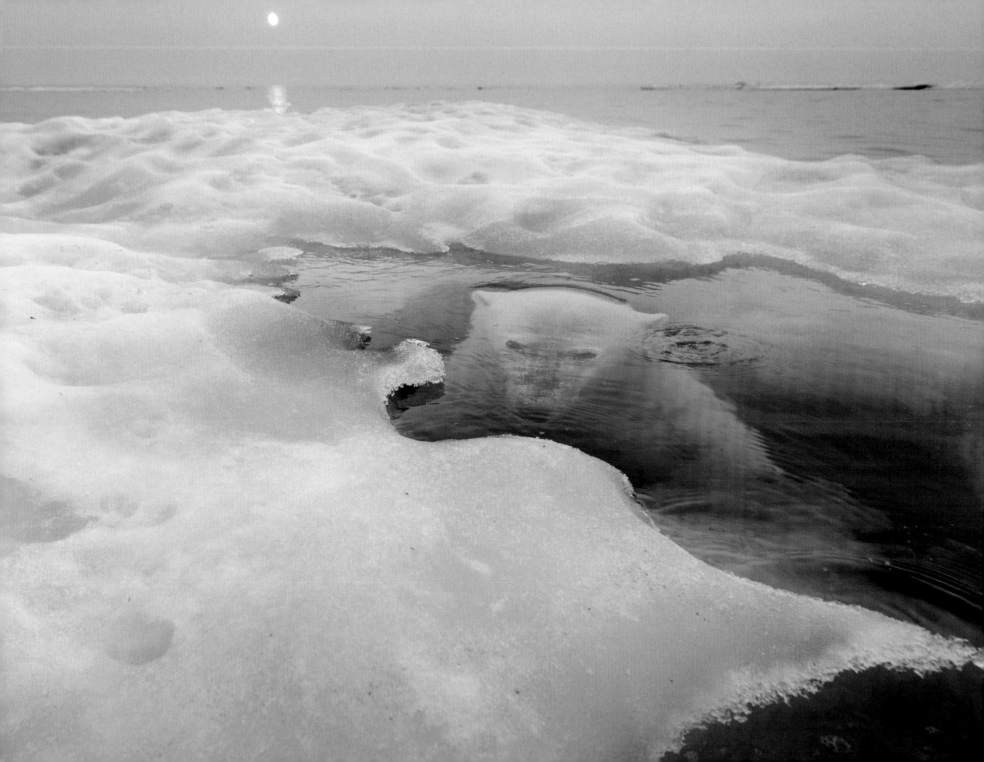

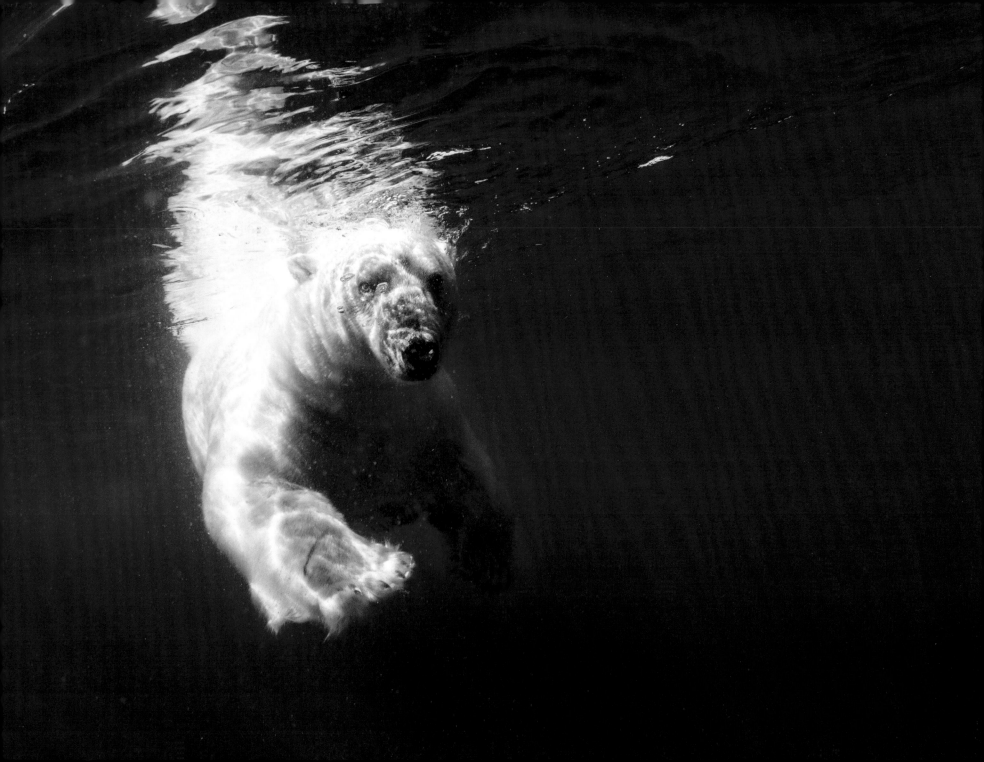

Polar bears hunt in all seasons . . . We've seen polar bears in the summertime that have caught a seal. There was a polar bear in a bay while we were boating in the summertime; the bear was eating a seal that it had caught. They have a very strong sense of smell. I find it interesting, and a learning experience, to just observe polar bears from afar, without them knowing that I am observing them. I once saw a polar bear on ice. The seals have dens between the ocean and the surface. This bear kept his head going up to smell and looking around, then going back down low to smell. That kept going on for a while. There was a breeze from the north; it wasn't a wind, just a breeze. The bear took a couple steps and started smelling again and looked around. It looked in one direction for a while, and then it started running toward what looked like nothing but snow. It stopped and went down on the ice; it dug deep enough that I couldn't see it anymore. But after a little bit of time, I saw it coming up backwards and it was dragging a big seal to the surface. I really enjoy watching polar bears when they don't notice that I'm watching. They really do hunt in all seasons.

—Solomon Awa, Iqaluit

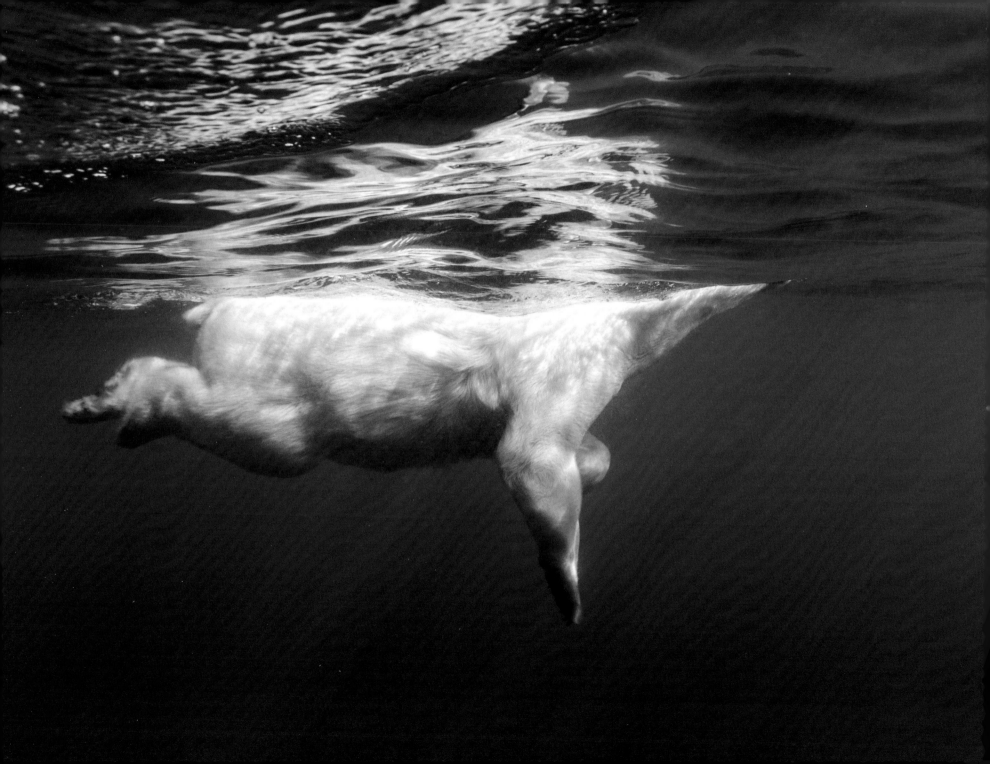

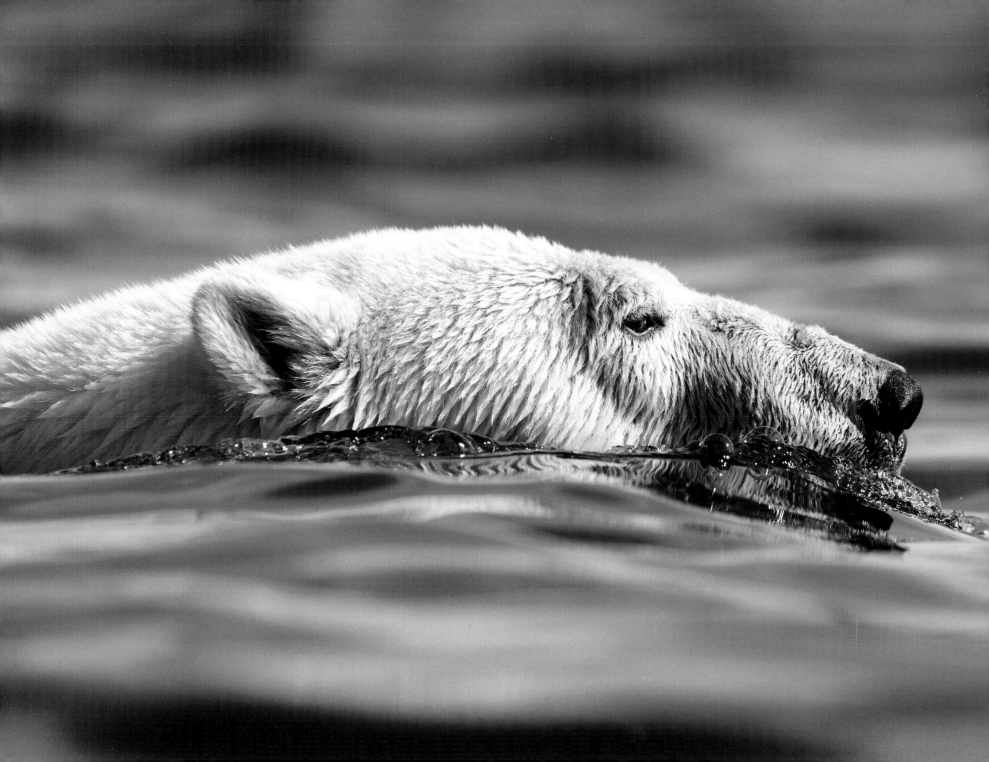

One time we went boating. We couldn't see the land because we were so far out. I saw eight sticks floating, so we went to check why they were floating. When we got closer, we saw two bears sleeping upside down with their legs up. I was shocked to see them. Only their legs and their heads were on top of the water. I thought they were dead, so we got really close to them, and they woke up and fled.

—*Darryl Baker, Arviat*

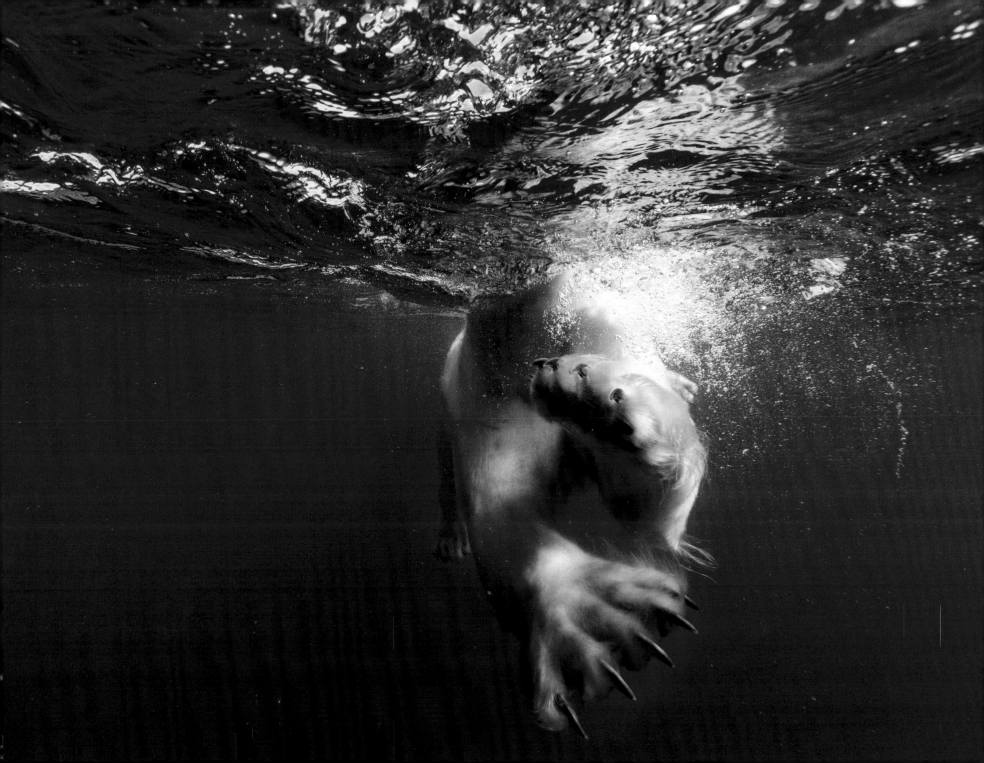

Before I could go polar bear hunting alone, my dad and I went polar bear hunting. I didn't know much about polar bear hunting yet. He taught me that just by looking at the footprints of a polar bear you could tell if it's a male or female . . . Female prints are more round. Male prints are pigeon-toed, and males drag their feet. You can't really tell if a bear is a male or female just by looking at it.

— *Geeold Kakkik, Pangnirtung*

Arviat, Nunavut

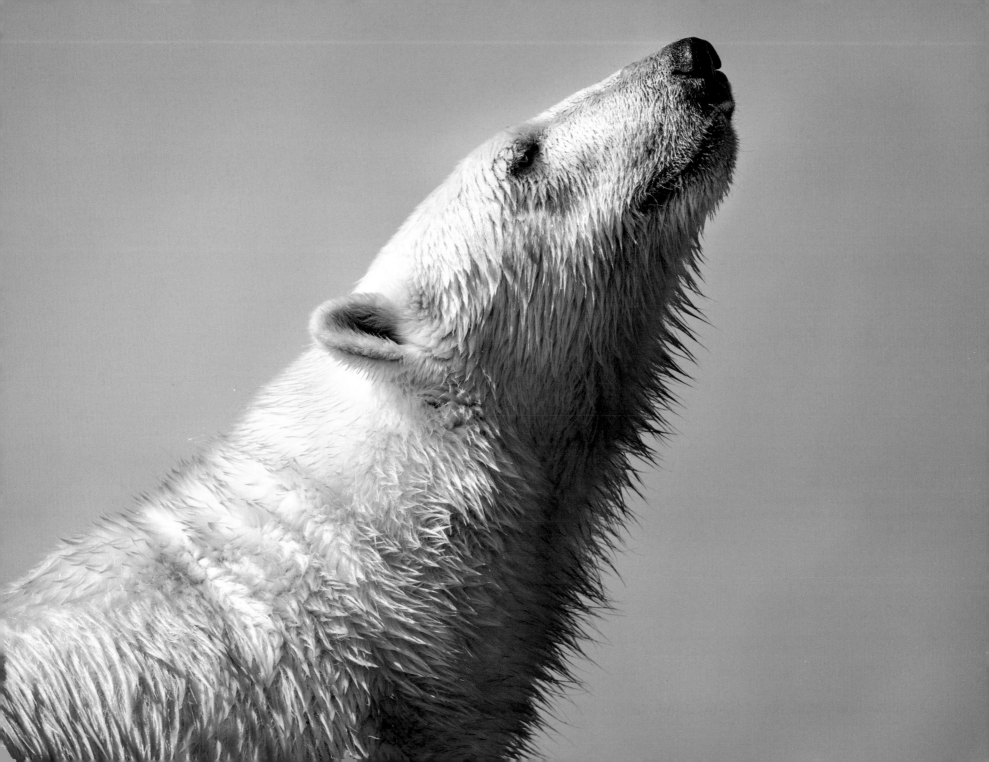

Polar bears are very strong. They can hunt for beluga whales, even though beluga whales are bigger than polar bears. They can hunt walruses, and walruses attack with their tusks. Walruses are slow, but they are very strong. They're even known to attack and kill orcas, but the polar bears can still hunt them . . . I haven't seen this, but I have heard a story about a polar bear. We as Inuit like to go have tea and relax by icebergs and climb up them to see the land with binoculars when it's possible. I have heard a man tell a story from around Grise Fiord. He saw an iceberg and travelled toward it to have tea and relax. He saw a dark figure on top of this iceberg. There was a polar bear on top of this dark figure. He wanted to see what it was, so he went closer to it. When he got closer to the iceberg, he used his binoculars to see what this dark figure was. He saw through his binoculars that it was a walrus with tusks. The polar bear had dragged it all the way up to the top of this iceberg. Polar bears are strong enough to do that, and that makes them scary. They are capable of breaking ribs in seconds.

—*Solomon Awa, Iqaluit*

Frozen Strait, Nunavut

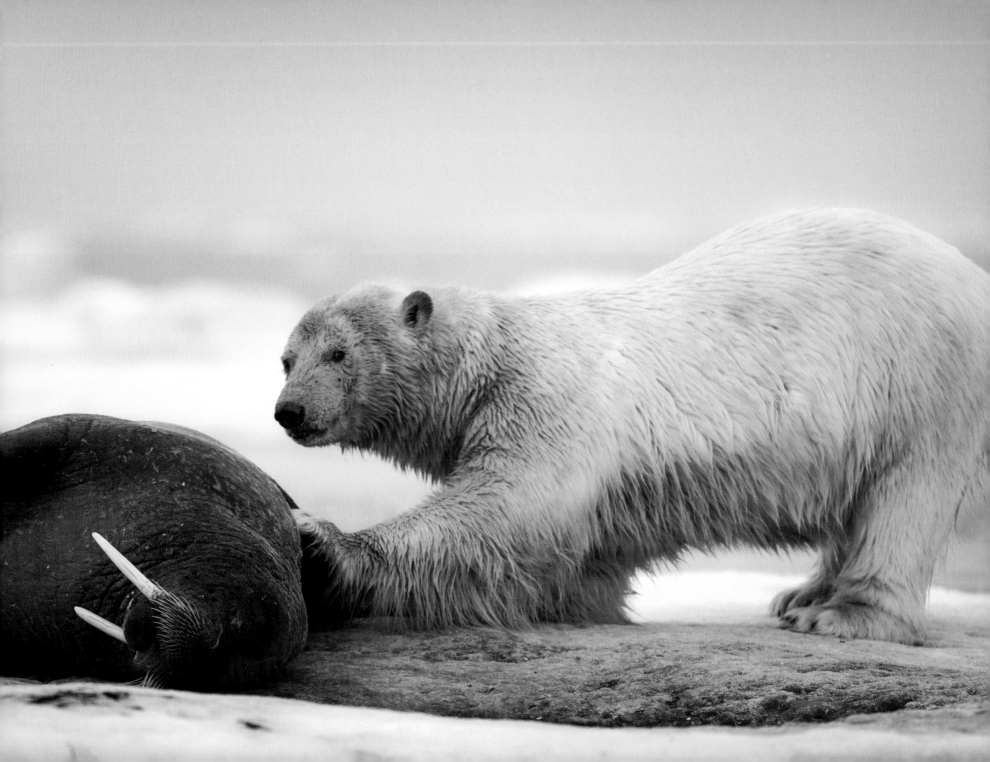

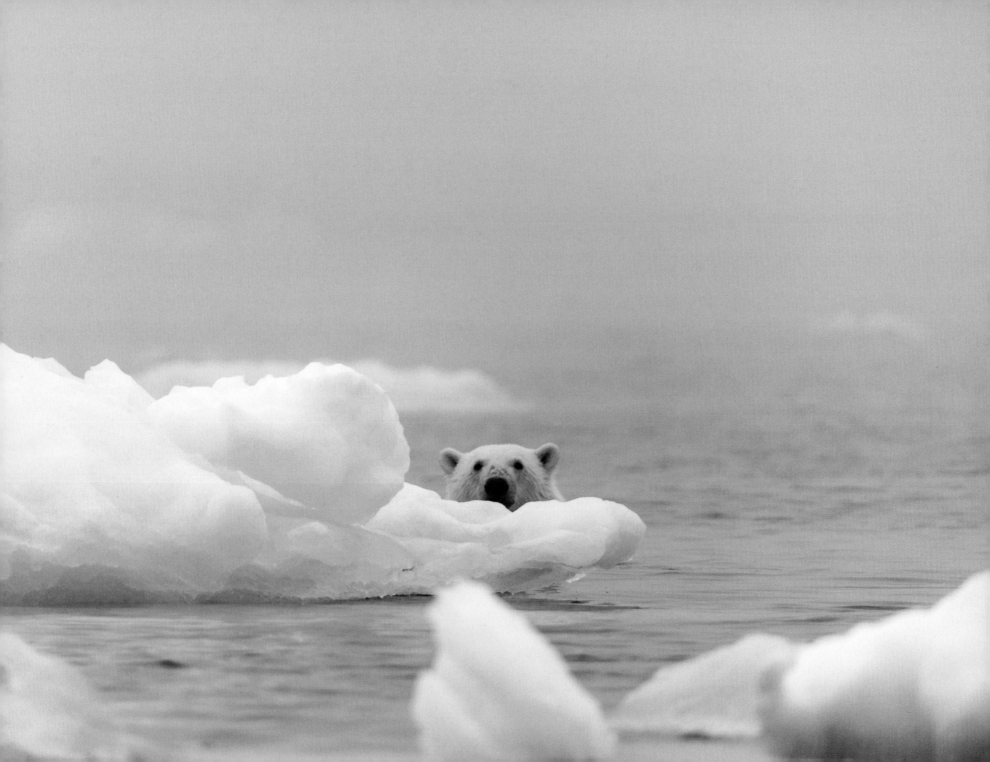

Polar bears hunt on ice pans very patiently and skillfully. They have to swim around the pans to try to reach the basking seals without making much sound. They are very wise and use their skills precisely to jump on their targets. They do not get cold when they are swimming in the water, as they can live both on land as well as in the sea. Inuit knowledge says their minds are comparable to humans' wisdom.

—Louise Flaherty, Clyde River

Hunters would say that we could tell if the bear was aggressive toward a hunter by the shape of its ears. If the bear's ears are dark and deep, it means it is aggressive and most likely to attack. If the ears are lighter and shallow, it is not as aggressive. Also, if the bear's attention is on the dogs and not so much on the hunter, it won't be as scary and aggressive, but if its attention is on the hunter and it doesn't mind the dogs around it, then it will most likely be aggressive and attack the hunter. I have heard this more than once from hunters, but I haven't experienced it myself and will not attempt to experience it.

— *Solomon Awa, Iqaluit*

Churchill, Manitoba

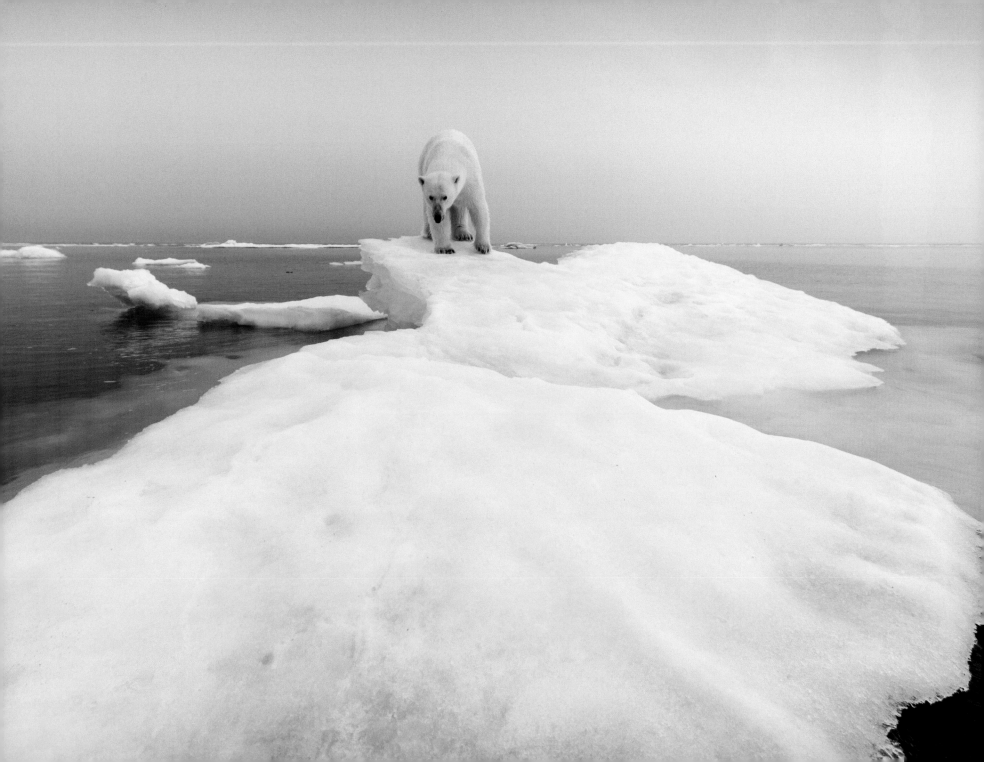

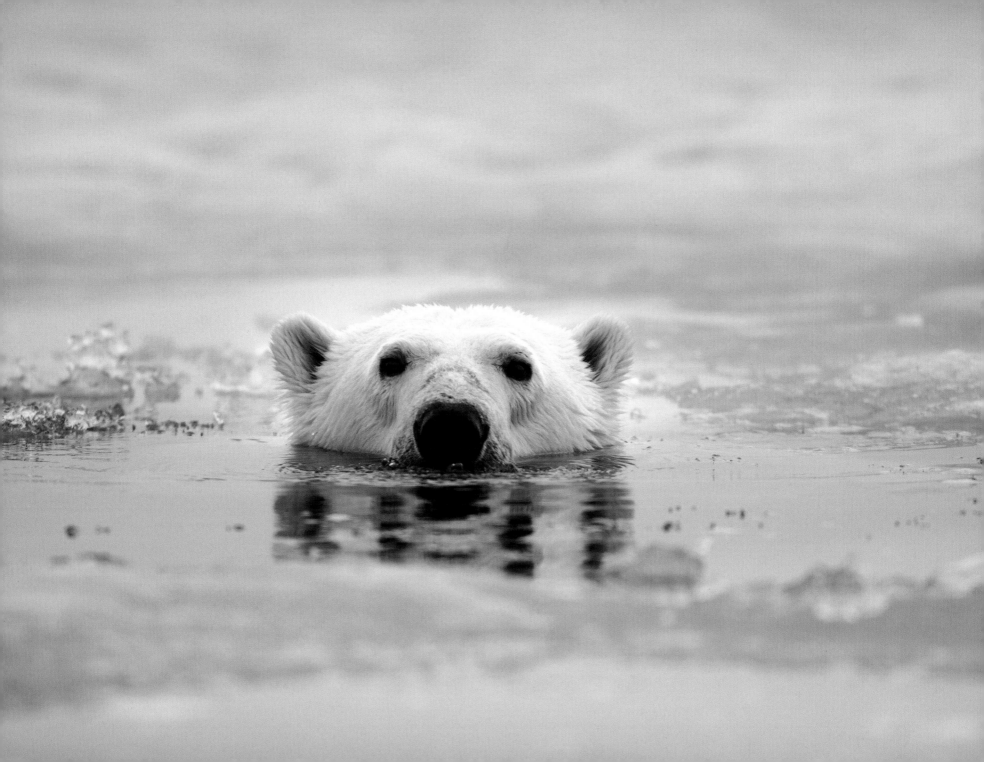

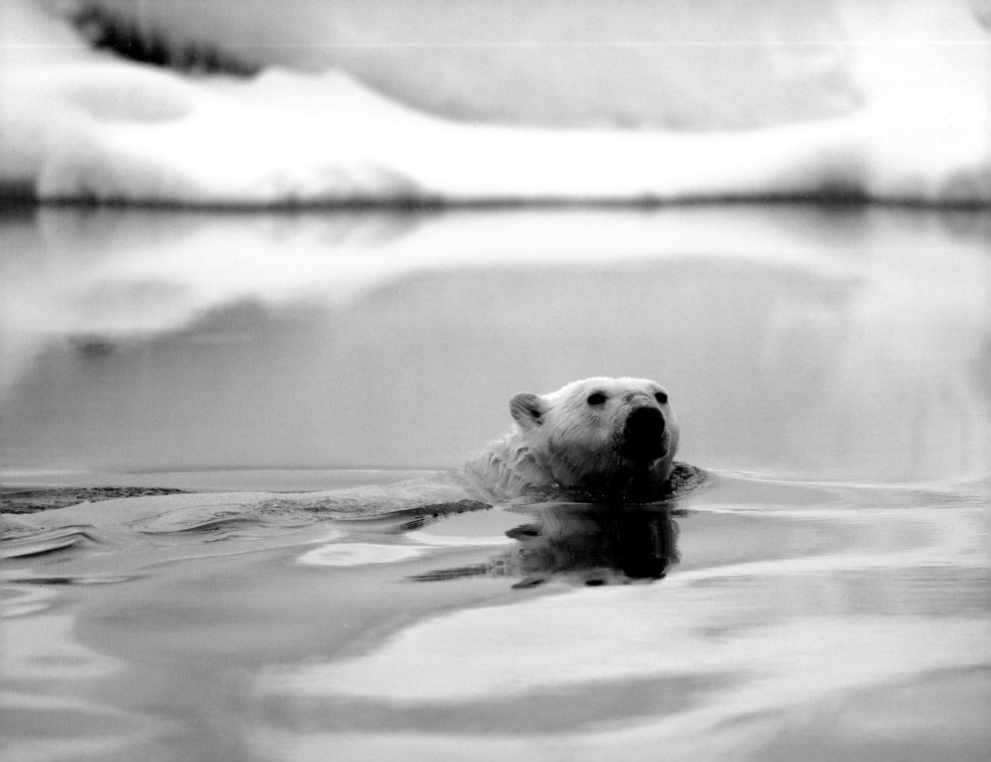

In addition to being excellent hunters, bears are scavengers, too. They will eat any dead animals they find, such as a big whale. Bears will eat the fat of a whale carcass before they eat the meat. They will stay with the carcass for days, or even months, using it as their main food source. Like any animal, bears will fight for the food, and the big, dominant bears will be the first ones to eat.

—*William Flaherty, Grise Fiord*

Svalbard, Norway

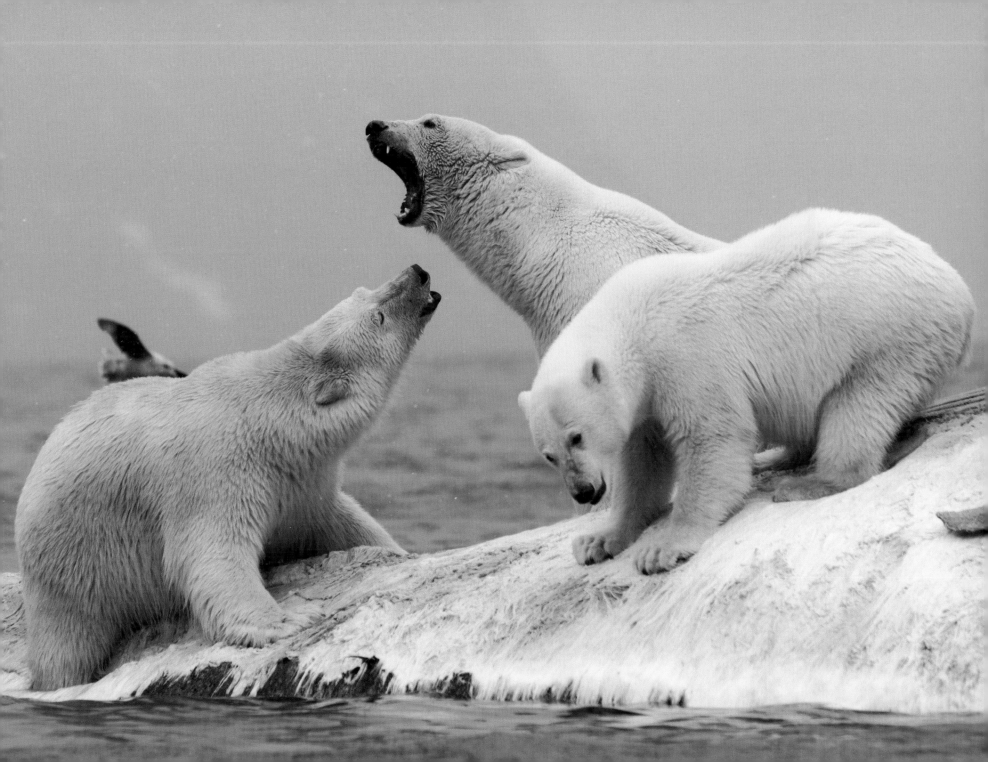

One time we saw a very large polar bear, a nanurluk, on the ice. We were boating between Rankin Inlet and Whale Cove. There was ice, so we could not get closer to it, but it was very big (although it was pretty far away). There were three boats, and the people with us all said that it must be a very large bear. Yes, I know it is true that there are nanurluit that are truly huge bears.

—Leo Ikakhik, Arviat

Frozen Strait, Nunavut

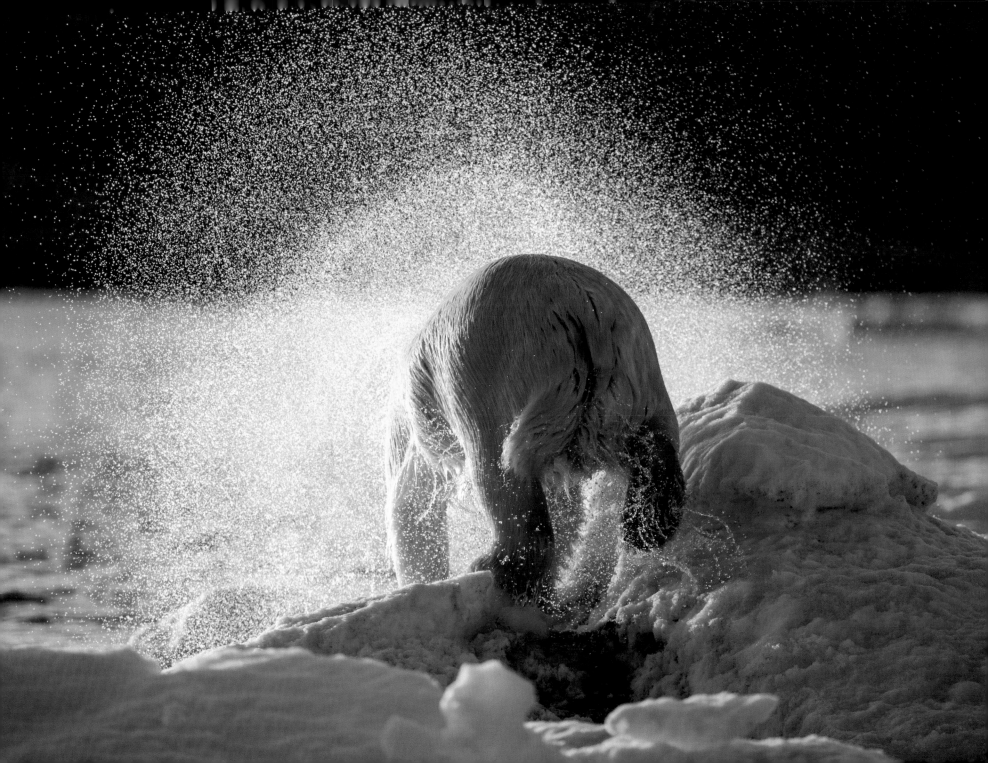

In Pond Inlet, we would go hunting to the floe edge when the ice wasn't too thin, and we would hunt seals at their breathing holes. After we caught seal near the floe edge, we went up to the land where there was a cabin to sleep overnight. Not far from the cabin there was an iceberg. Icebergs are large; they are much bigger than houses and some go up as high as a six-storey building. Some icebergs are steep, and some are vertical. We saw a polar bear near the iceberg, and we were just observing it. As we got closer to the bear, it ran toward this huge iceberg that was perfectly vertical. We got closer to the bear just to observe. We thought it would stop by the iceberg, but the bear climbed up this iceberg using its sharp claws. We had our rifles ready, just in case the bear came toward us. We stopped our snowmobiles and we could hear the claws against this iceberg. This iceberg was almost perfectly vertical and the polar bear managed to climb on top of it. It was unbelievable. Polar bears are very strong and capable of anything.

—*Solomon Awa, Iqaluit*

Hudson Bay, Nunavut

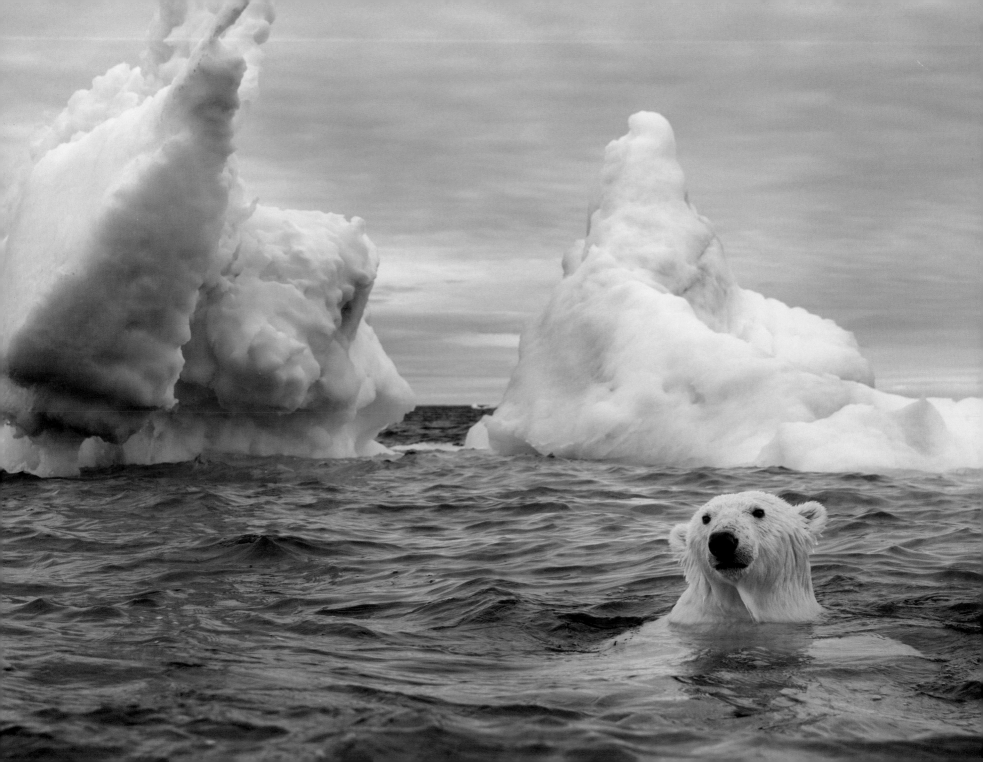

A bear had been stalking our research cabin. I had my shotgun out and ready in plenty of time. I watched it and waited near the cabin, confident, with my gun ready and slugs in the magazine. It was only after the bear was gone that I tried to cycle the action to remove the slugs and realized it was frozen solid. Unusable. Useless against an attacking polar bear.

—*Tony Romito, Resolute Bay*

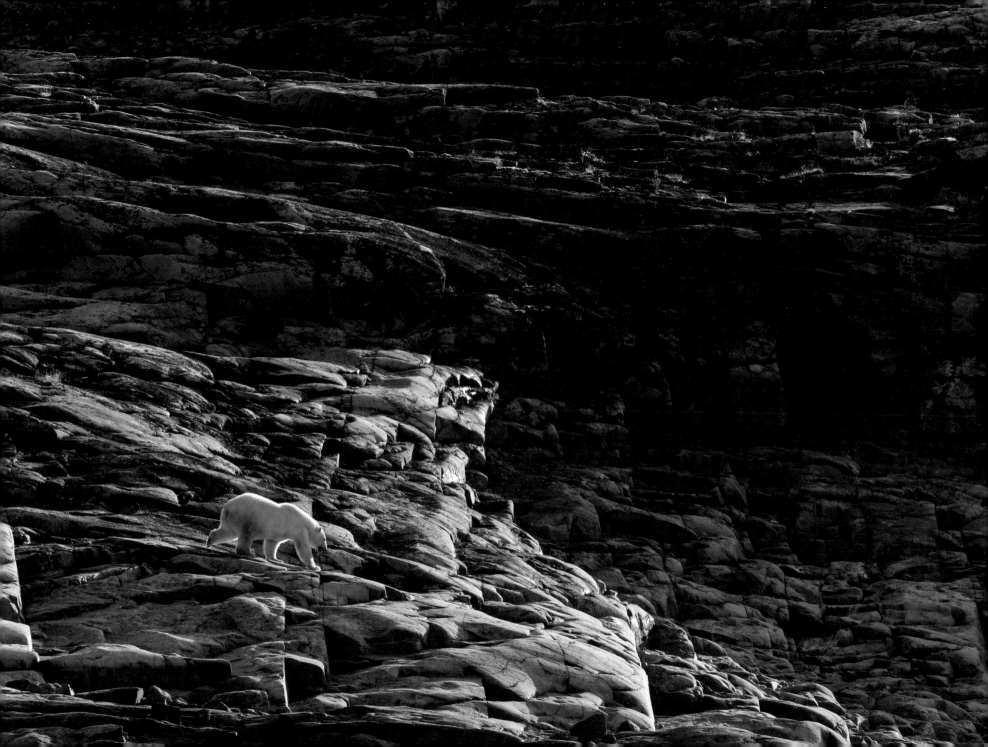

My aunt gave me very short notice telling me that I would go boating with her and her family. We heard there were a lot of polar bears. We looked around while we were boating; we weren't too scared because we knew they couldn't get into the big boat. There was a bowhead carcass . . . there was more than one polar bear feeding on it. Someone started counting the bears that were feeding on the carcass and there were around forty, but that wasn't all. They reminded me of dogs while they were feeding on the carcass . . . The reason they reminded me of dogs was because when the other boat went around the island, they would run from the boat together. There were so many bears that time.

—*Peepeelee Kunilusie, Pangnirtung*

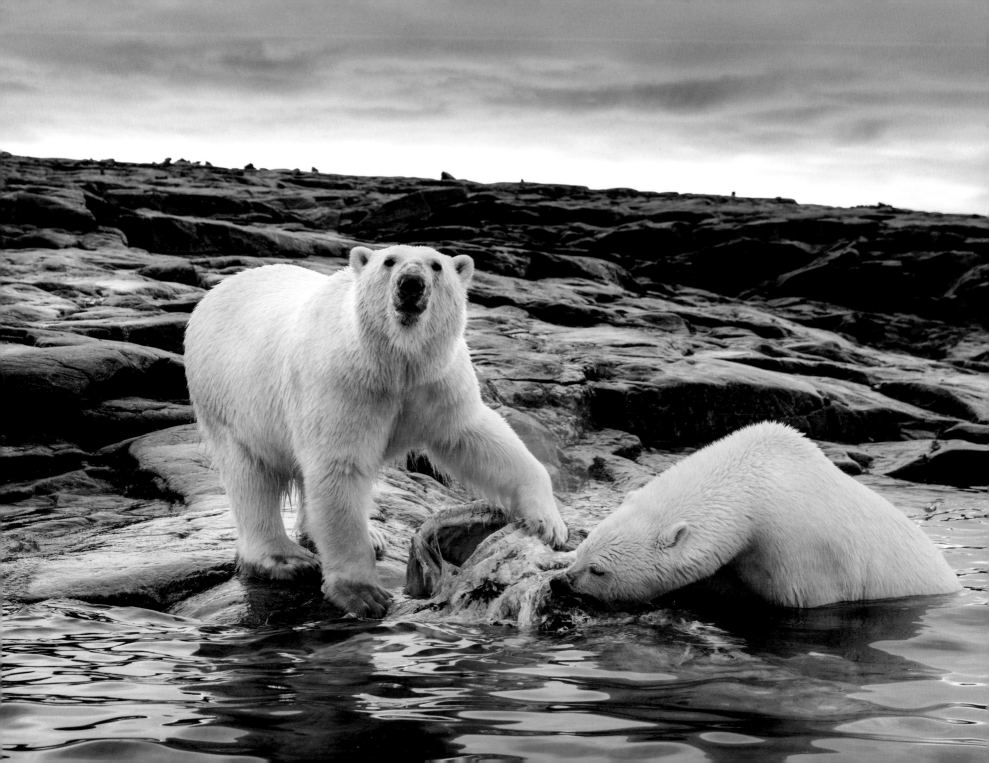

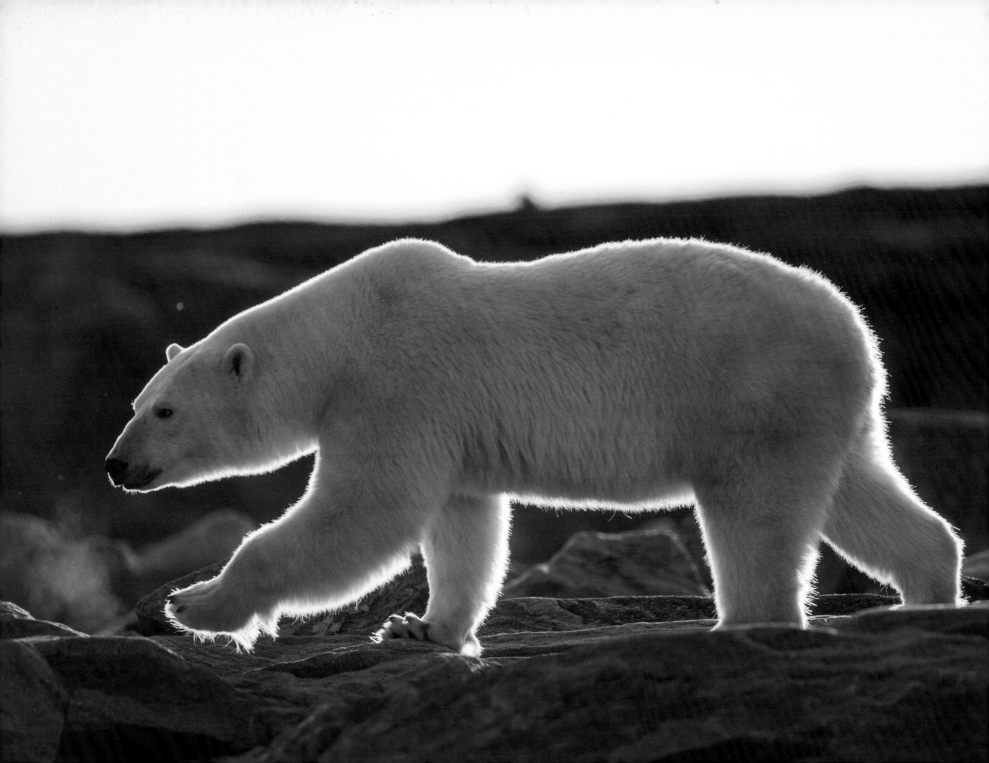

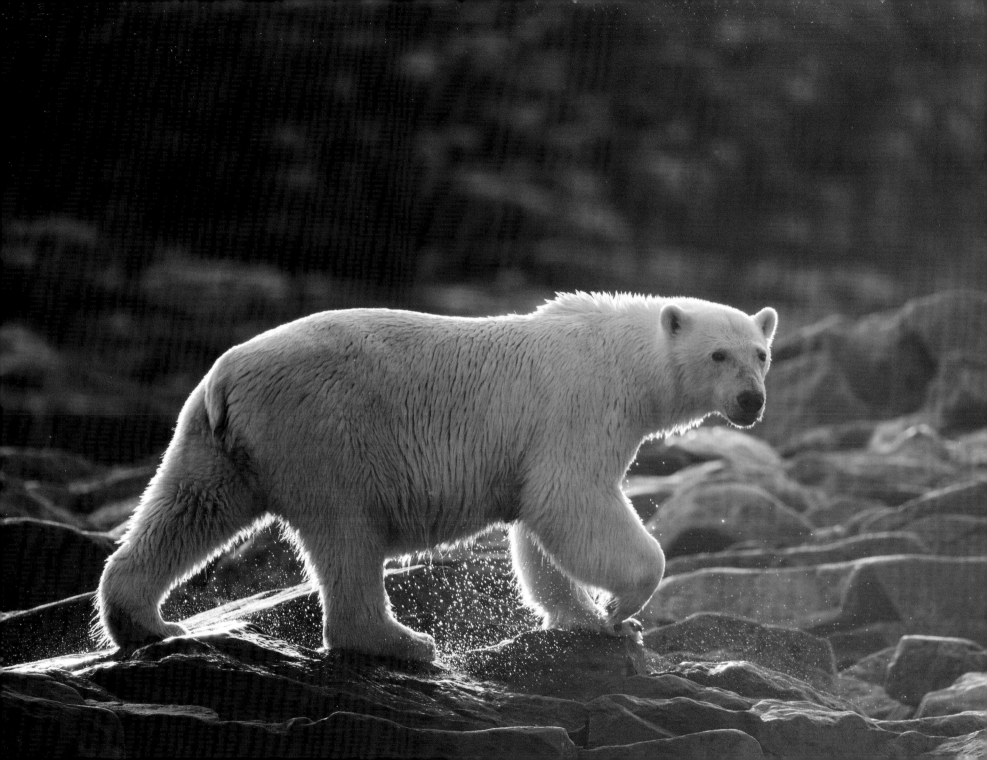

We were told to always be prepared for attacks. All animals know to defend themselves from predators, including polar bears. If a polar bear ever runs toward you, keep in mind where the head is tilted. A polar bear will not run with its head straight; it has to be tilted. Also know that it is easier for the bear to look down than up. If the head is tilted to the right, quickly move to the left. Always move to the opposite side of where the head is tilted, because the bear can't make a sudden stop because of its weight. When you move to the side and the bear stops, it will still have to slide toward the direction it was running to turn. You will have more time to escape while the bear is trying to stop and turn. That is a very good thing to know, but we know not everyone can move that quickly, and we've heard of people being attacked by polar bears. When polar bears attack, they will not always kill. They defend themselves by attacking because they are scared and don't want to be killed.

Another thing to know if you can't escape from the attack is protecting yourself by having your arm in a vertical position. If your arm is horizontal, the bear will bite it, but if it's vertical, it'll be harder for the bear to bite your arm. We also shouldn't bother the bears if they're hunting by the seal breathing holes, because the bears will get angry. A bear can go from not planning to come at you to attacking you if it is bothered while it is hunting.

—*Solomon Awa, Iqaluit*

Repulse Bay, Nunavut

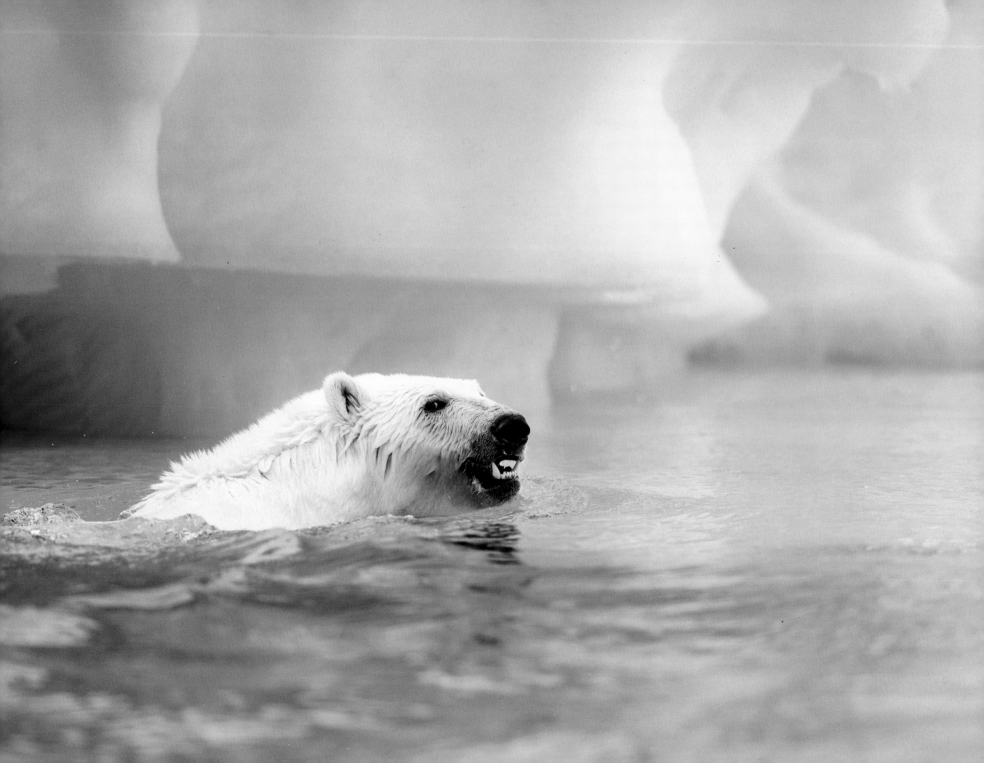

When you have dogs, bears are very annoying now. Bears usually don't attack, but those young bears that are not with their mothers are the ones that tend to go to where the dogs are tied and take their food. Those kinds of bears are the most dangerous.

I had some dog food inside an electric fence with a camera. When the wildlife officer showed me the video from the camera, it showed that a bear would run away a few minutes before I got there. I thought there was no bear, but it left before I got there. When it heard the Ski-Doo starting it would run away.

—Darryl Baker, Arviat

Hudson Bay, Manitoba

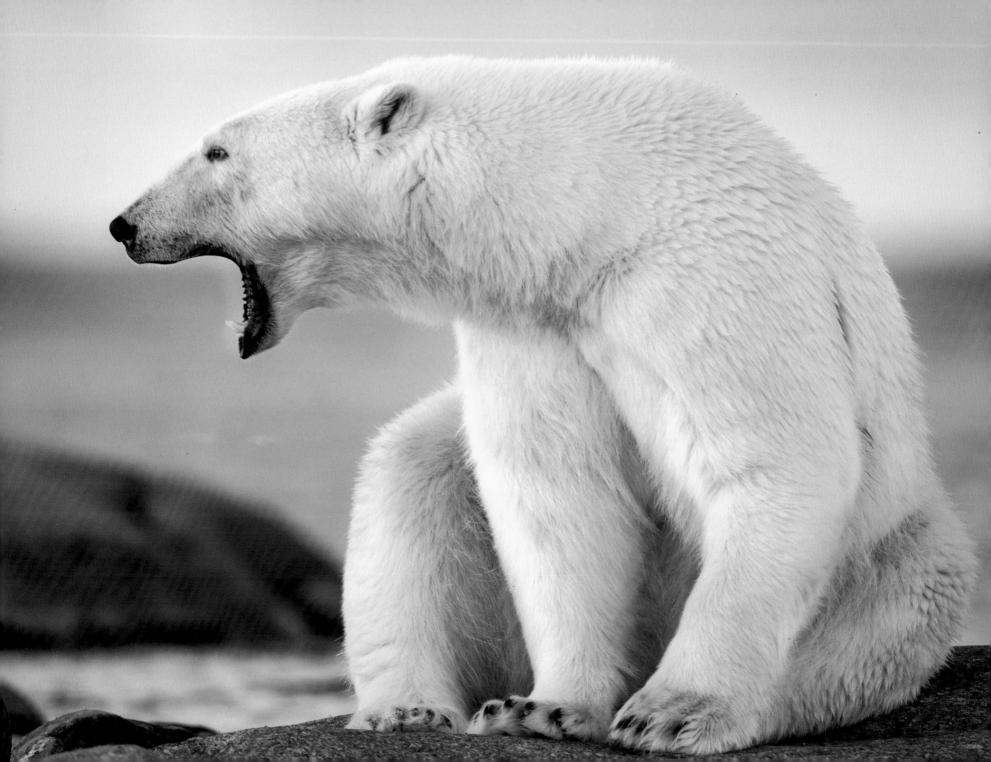

Looking back, there was nothing really routine about those days. We were tracking and tagging polar bears in the middle of the frozen Canadian Arctic. This was a dream for me. The realization of a childhood spent outdoors camping, fishing and hunting, observing nature, and being fascinated with wild animals and wild places.

We had spotted a bear—it may have been the third or fourth sighting of the day. As always, I was in the back seat of the four-seat helicopter. The biologist was up front beside the pilot, keeping an eye on the bear.

With the bear spotted, I loaded the tranquilizer gun for the biologist and waited for the pilot to set down. I gathered my shotgun (still in its case), the portable radio, and the emergency jerry can of fuel. I stepped out of the helicopter onto the sea ice and walked about thirty feet away. The helicopter lifted off in the direction of the bear.

This was protocol. Removing myself, the weight of the emergency fuel, and my safety gear allowed the helicopter much more maneuverability, and the biologist much more space to get off a good shot at a galloping polar bear.

I never really got used to the silence and feeling of vulnerability that I felt when the helicopter disappeared from view. I was left in the middle of the Arctic Ocean, hundreds of miles from anywhere, with a gun and a radio. In that situation, one feels quite small, slightly insignificant, and anxious for the safe return of the helicopter once the bear has been darted. On this occasion, like all others, I assessed where I was and where I might go if the helicopter did not return. I was put on the ice close to a small island. It had sheer rock cliffs on the side I was facing and was quite magnificent to look upon. I turned and looked out to the sea ice for any signs of

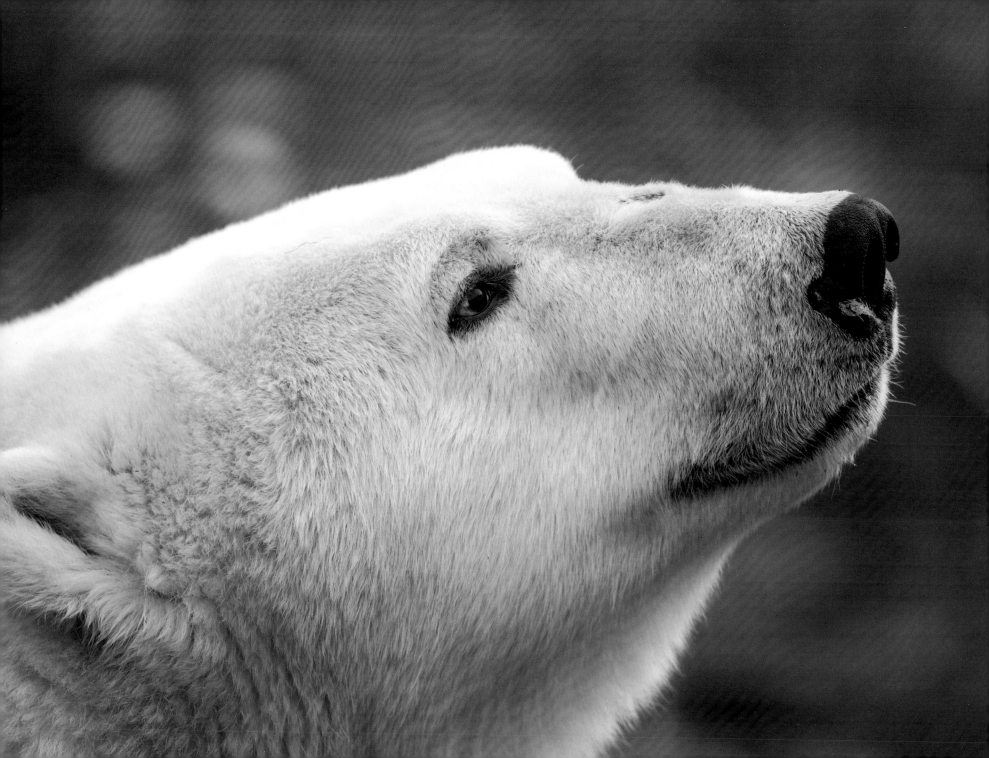

danger. My boots crunched in the snow as I moved and seemed terribly loud in such vast quiet.

I heard something strange behind me . . . like a "woof." My heart stopped. I turned toward the cliffs and searched the broken and jumbled sea ice. Nothing. I strained my ears and definitely heard something else, but there was nothing to see. I searched the area intently, noiselessly, until I was satisfied that what I had heard must have been ice settling with the tide.

I turned back to the open ice and listened again for the helicopter, which I could no longer hear.

Then I heard a much louder bark behind me. I turned around quickly, and then I saw it—or rather them. Two very large polar bears emerged from behind some ice at the base of the cliff. I froze. I was probably about fifty to one hundred yards away. The bears did not look directly at me and were moving slowly from the right to the left of me, along the cliff wall. I think I noticed when my heart started beating again as it kind of kicked me into gear.

I looked down at the shotgun, which was packed away in its case. I glanced over at the radio, also packed away in a case. Both required unpacking and assembly to be operable—and this would take time.

I looked back up at the bears. They were making all kinds of noises and being aggressive with one another—a behaviour I was not familiar with. One of three things was happening with those bears . . . They were a mating pair getting frisky with one another, and were getting ready to eat me. Or, they were a couple of males competing for dominance, and were getting ready to eat me. Or, they were simply hungry and discussing which parts of me they each wanted, and were getting ready to eat me.

Repulse Bay, Nunavut

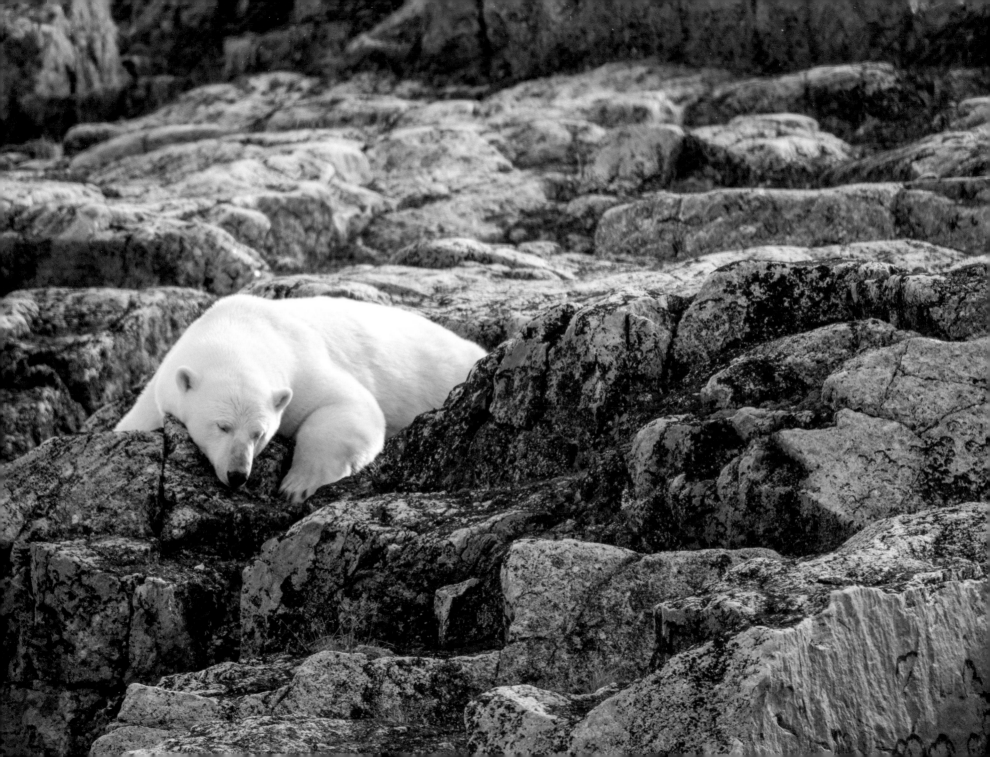

The bears were getting closer. Sidling their way over to me. I looked back at the gun case and the radio case. Each of these items was there for my protection— each one had an equal chance of failure or success.

The bears were getting closer.

The radio needed to be unpacked, antenna assembled, turned on, dialed into the frequency that the helicopter pilot was monitoring, and it relied on me being able to relay a coherent message. And what the heck was the frequency again?

The bears were making more noise, getting more aggressive with each other as they got closer.

At this point, the bears had not even looked in my direction. I knew enough to realize that that was certainly not an indicator of their indifference. They got closer.

I decided to act. Every once in a while, I could hear the helicopter over the wind. They were still in the air and not too far away.

The radio.

Trying not to draw any undue attention, I bent slowly and pulled the radio case toward me. My mitts were too bulky, so I had to take them off to get into the case.

The bears were still playing it cool, not looking at me as they continued to get closer. They were now making really weird huffing and snorting noises.

I opened the case to pull out the radio body. I found the antenna and tried to screw it on. If anyone has ever tried to screw on something small with frozen fingers, you will appreciate the difficulty I was having. Not to mention I had my eyes trained on the bears the entire time—so I was sort of feeling my way through the process.

Finally, I felt the antenna connect with the threads on the radio and quickly screwed it together. I pressed the "ON" button and prayed that the batteries were charged . . .

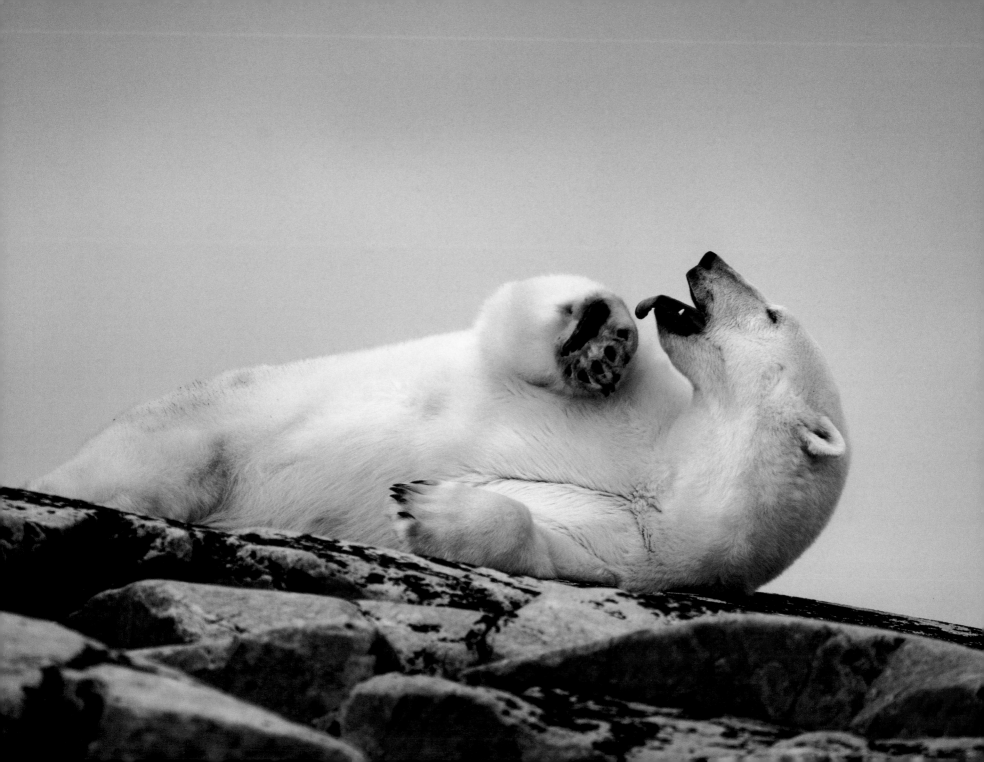

Success! The radio beeped to life. I looked at the bears as they continued to saunter my way—they made no visible recognition of me or the beeping radio.

The frequency came back to mind and I dialed it in. Then I paused.

I felt like my life was in danger and I was close to losing control over my bowel function. I wondered what I would say—and how it would come across. I spent far too much time thinking about how I could sound calm and unconcerned to the biologist and pilot.

The bears were about the closest they could come to me without changing their parallel course and deciding to come directly toward me. I imagine they were about forty yards away.

Throwing radio protocol out the window, I managed to say, "Hey, guys," and waited for a response.

No response.

I launched into it.

"I've got a couple of friends over here and it would be great if you could swing over and run them off."

Then the bears looked at me . . . directly at me.

Silence from the radio.

More silence.

"We'll be right there," crackled over the radio.

I watched the bears and they both watched me. I'm not sure who blinked first.

Relief hit me like thunder as the helicopter came blasting around the corner of the island, sending the two bears scampering away from me.

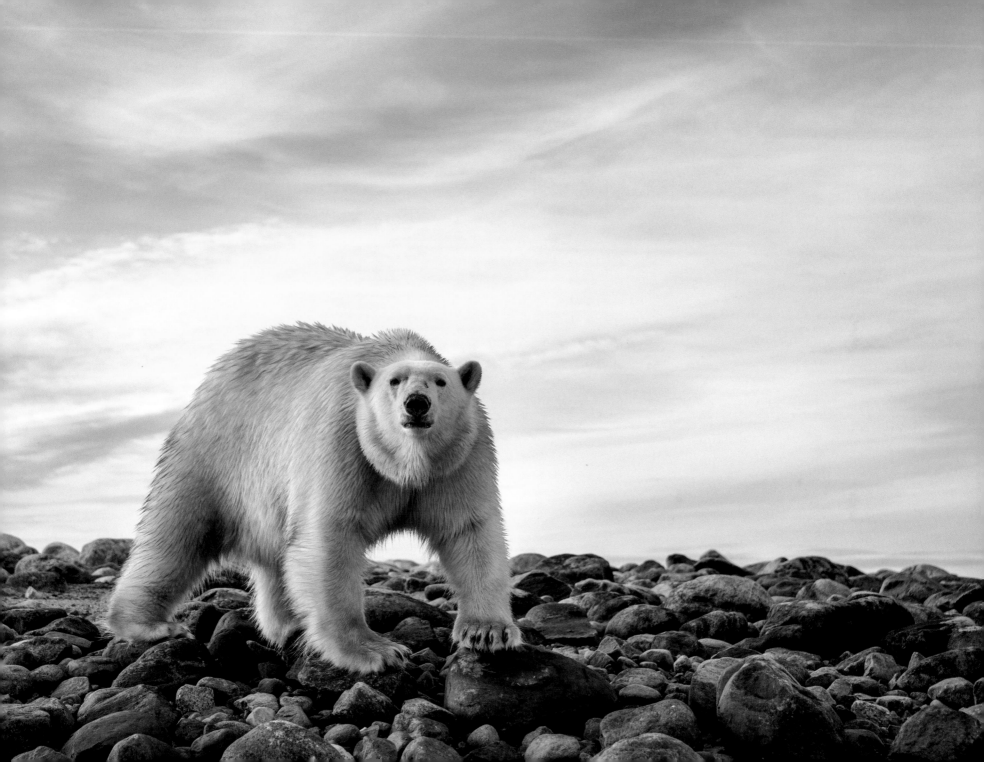

I relaxed and looked forward to climbing back into the safety of the helicopter and away from those two clever bears.

The helicopter flew right over me with no sign of landing and followed the bears around the island until they were both tranquilized. I waited another fifteen minutes on the ice until finally the helicopter returned to pick me up.

I said thanks as I jumped in to see wide grins from both the pilot and biologist. Over the next few days, I imagined this kind of thing happened all the time in the field with these guys. They seemed unimpressed by my story—either that or they were just silently grateful that they didn't lose the "kid" that day to hungry bears!

—*Tony Romito, Resolute Bay*

Repulse Bay, Nunavut

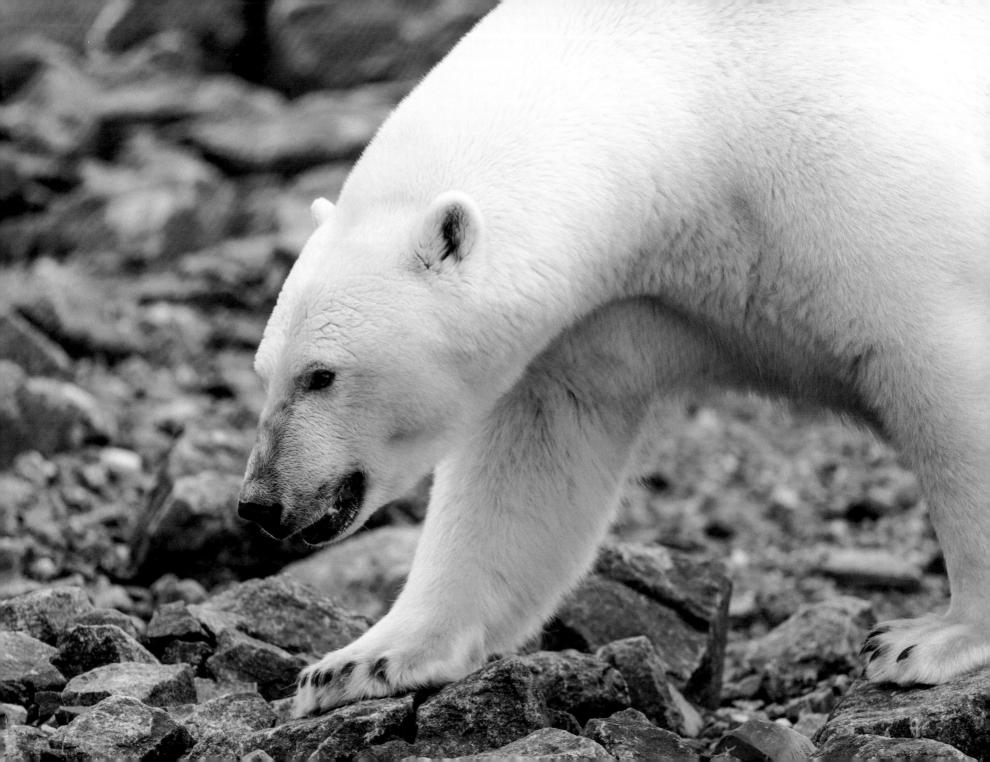

A bear was out walking, and there sat an owl on its hill. The bear came up to the owl. Then the owl spoke up and said:

"Old wanderer, are you out walking as usual, out wandering again?"

The bear answered:

"You that always stands straight up like a pillar, are you standing there staring as usual?"

Again the owl said:

"Old wanderer, out walking again, walking, walking, walking?"

The bear did not bother to say more, but started up suddenly to catch the owl. But the owl spread its wings and flew away.

—*Inugpasugjuk, traditional story recorded in the Igloolik area, 1920s*

Repulse Bay, Nunavut

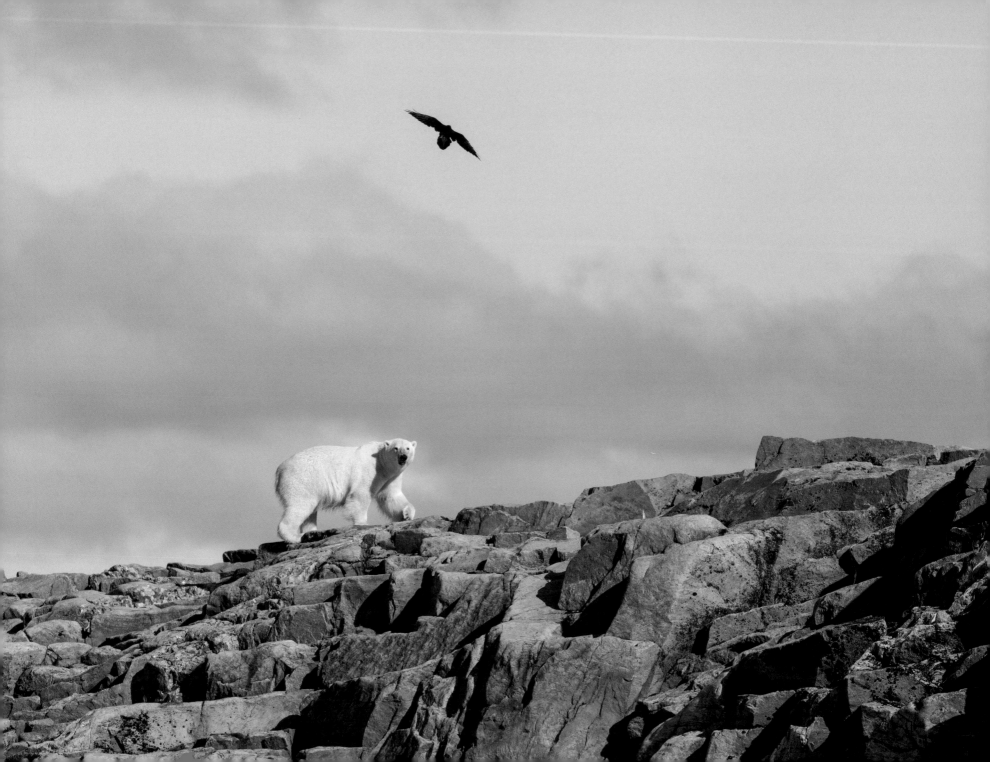

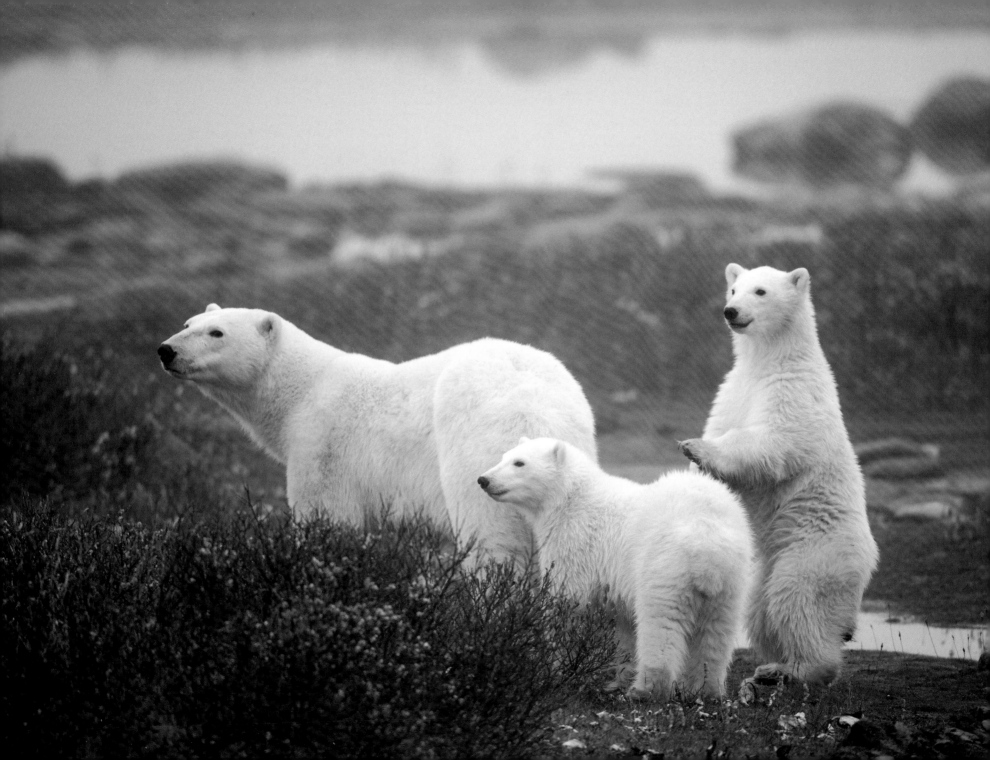

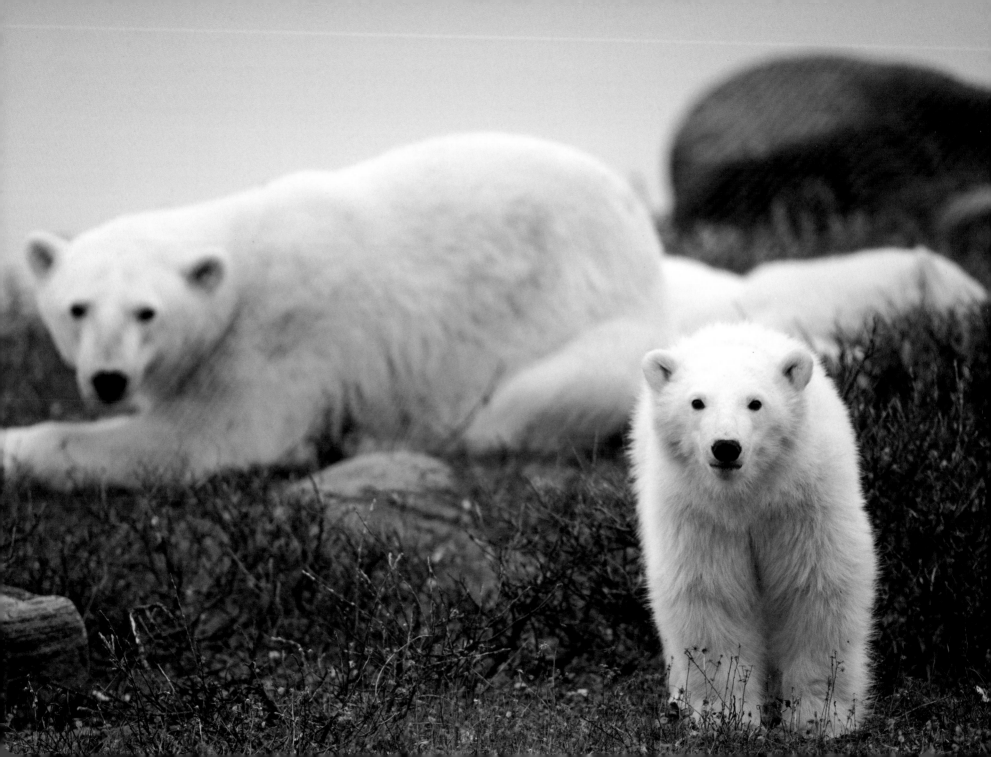

My brother adopted a cub. It would play with the children, sliding with them, and we all really got attached to it and loved it very much. One time the cub got lost when it was as big as a dog. One of our dogs followed it. My mother was outside sitting on the ground and working on a sealskin, and she saw two dogs running toward her. Lalaaq [the polar bear cub] came right up to her and hugged her really tight. She was apparently running away from the dog that was following behind her. We all got attached to her and loved her . . .

The bear had grown big. It was summertime, and very nice out. Ivaasaq [my son] had just started walking, and I couldn't find him. I went to look for him behind the house, to where the bear was tied, and saw him patting the bear on the head as the bear lay on the ground. I was really panicking, thinking the bear could kill him, but the cub was really friendly . . .

A ship, the C.D. *Howe*, started coming in to do chest X-rays on Inuit, checking if we had tuberculosis. They took the cub to the ship, made a cage for it, and left. We could hear the cub crying for miles as the ship left, and some of the people started crying listening to it mourning. That was so heartbreaking when the bear was taken away.

—Rhoda Karetak, Arviat

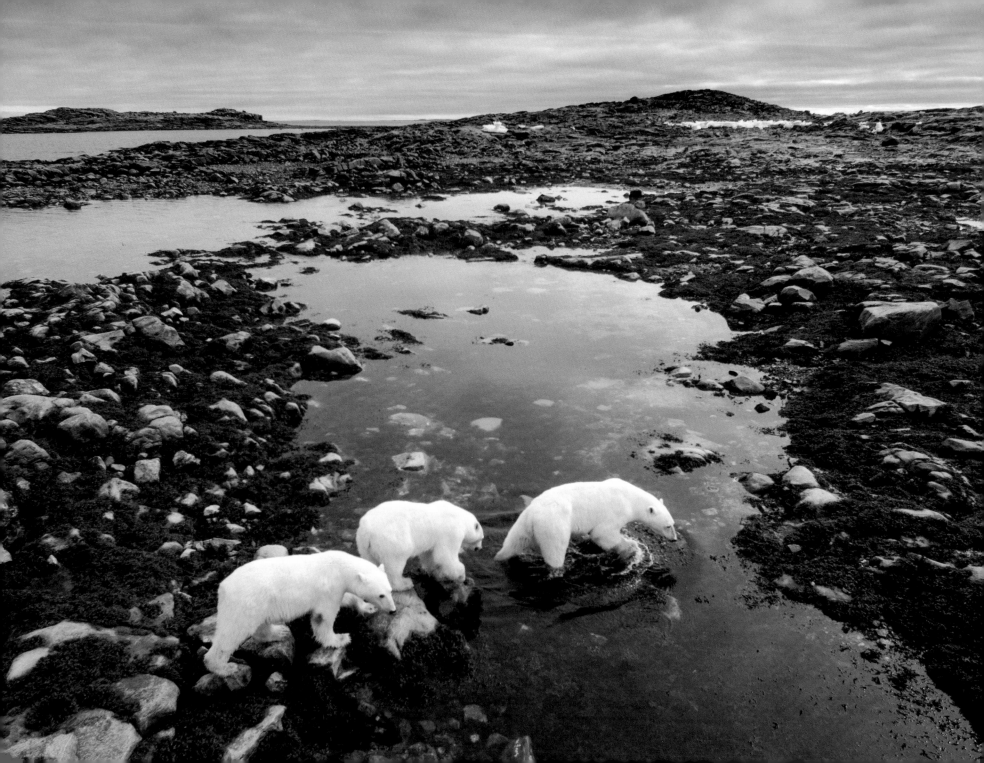

Polar bears stay in their dens in the wintertime. Large male polar bears start to come out of their dens when it gets really cold in January, and females with cubs usually start coming out in mid-March.

Mother bears training their cubs to walk don't go too far away from their dens for a few days. They go back to their dens to rest their cubs, then they walk farther away. That's how they train their cubs to walk.

— *Jerome Tuttuinie, Rankin Inlet*

Churchill, Manitoba

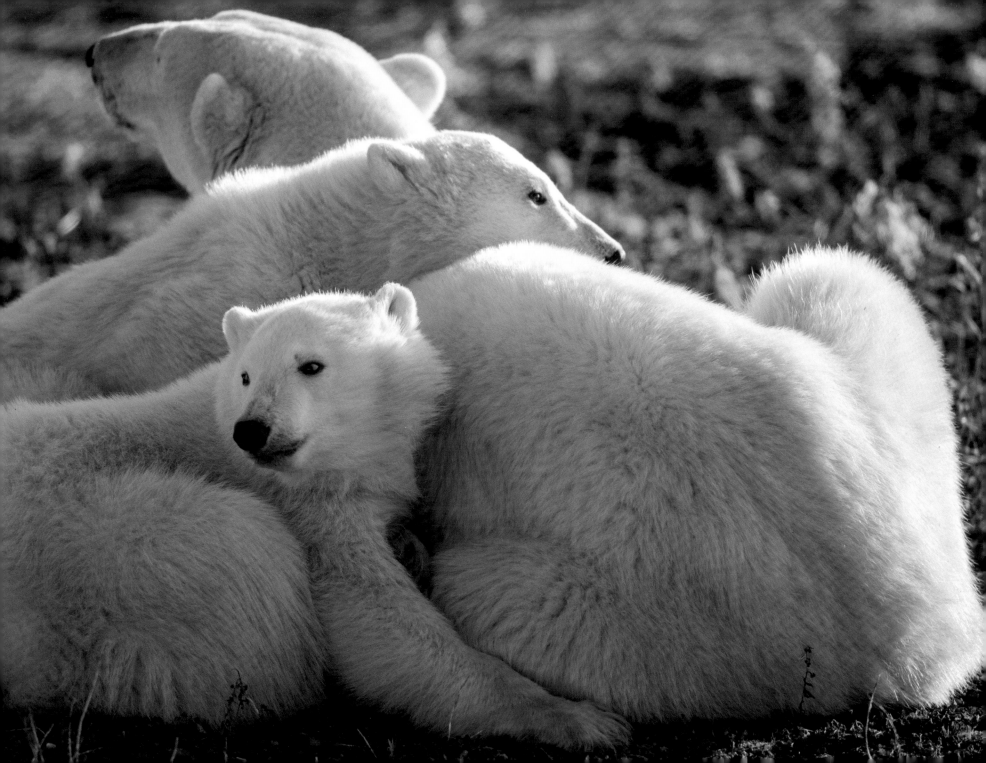

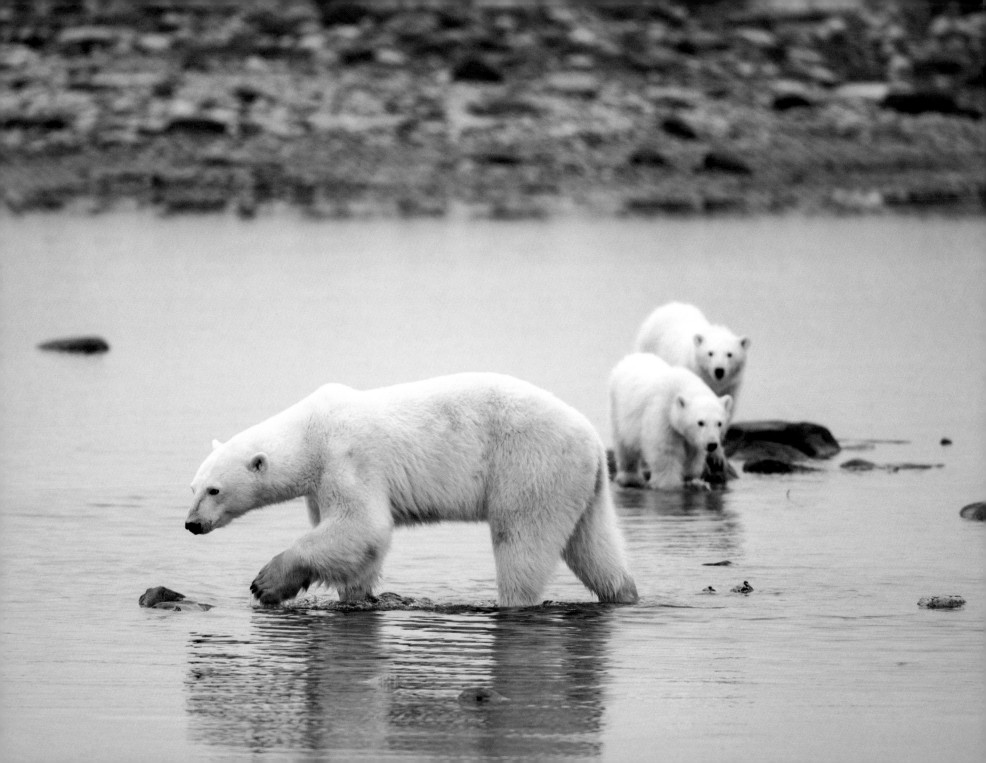

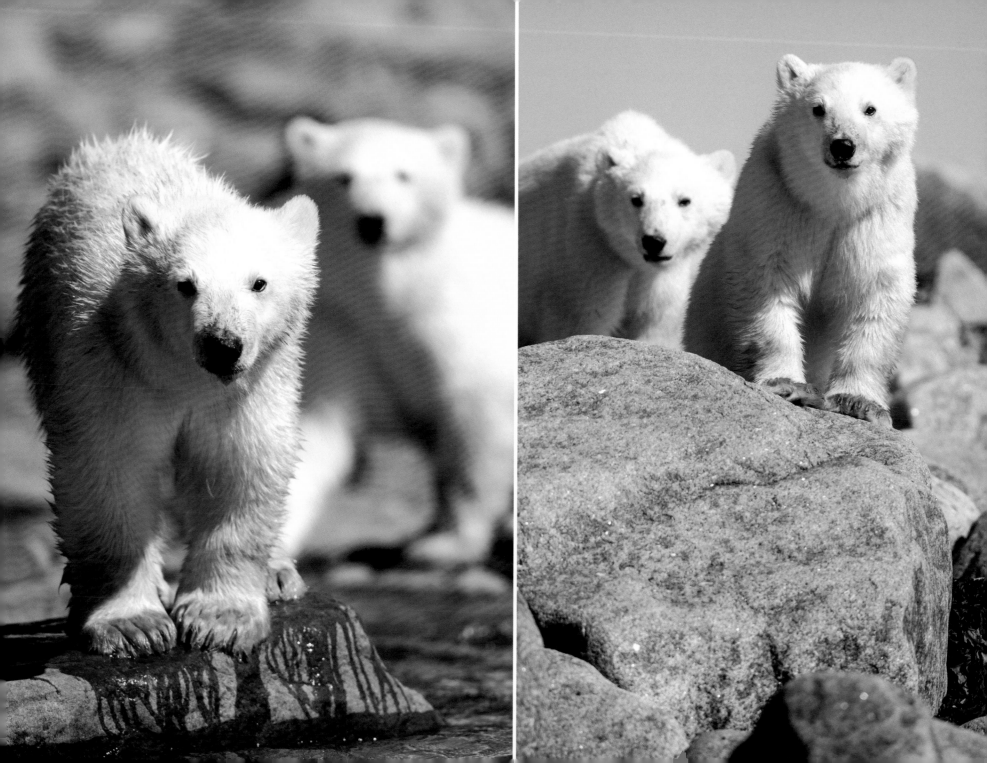

When you try to scare them off, sometimes bears can attack you, so you have to be very careful and watch how they are behaving . . . Sometimes when you get too close and when it's about to attack, the ears perk up right to the back . . . I always try to have my gun ready, just in case of an attack, or I make sure that I can turn my vehicle around. Some bears can attack and become dangerous when they are protecting their cubs. Bears without cubs are easier to scare off.

When a bear is ready to attack, it usually puts its head close to the ground with ears perked right to the back of its head. When they are positioning to attack, you have to be ready for it to charge. When they are walking around they are slow, but when they are attacking they can move very swiftly.

—Leo Ikakhik, Arviat

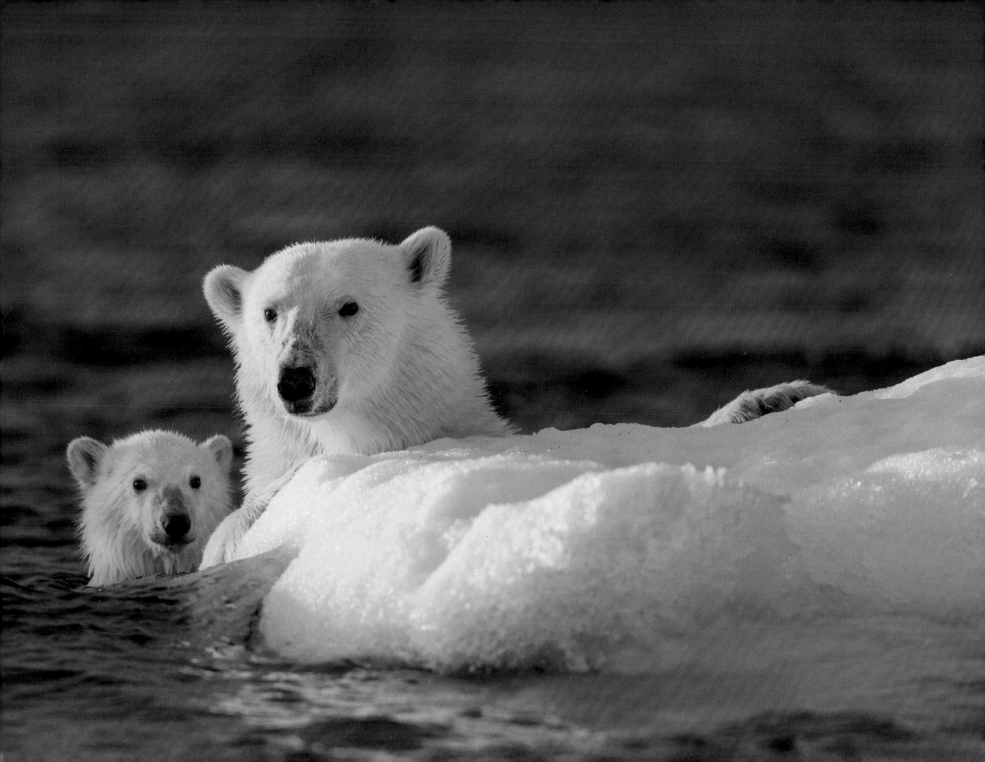

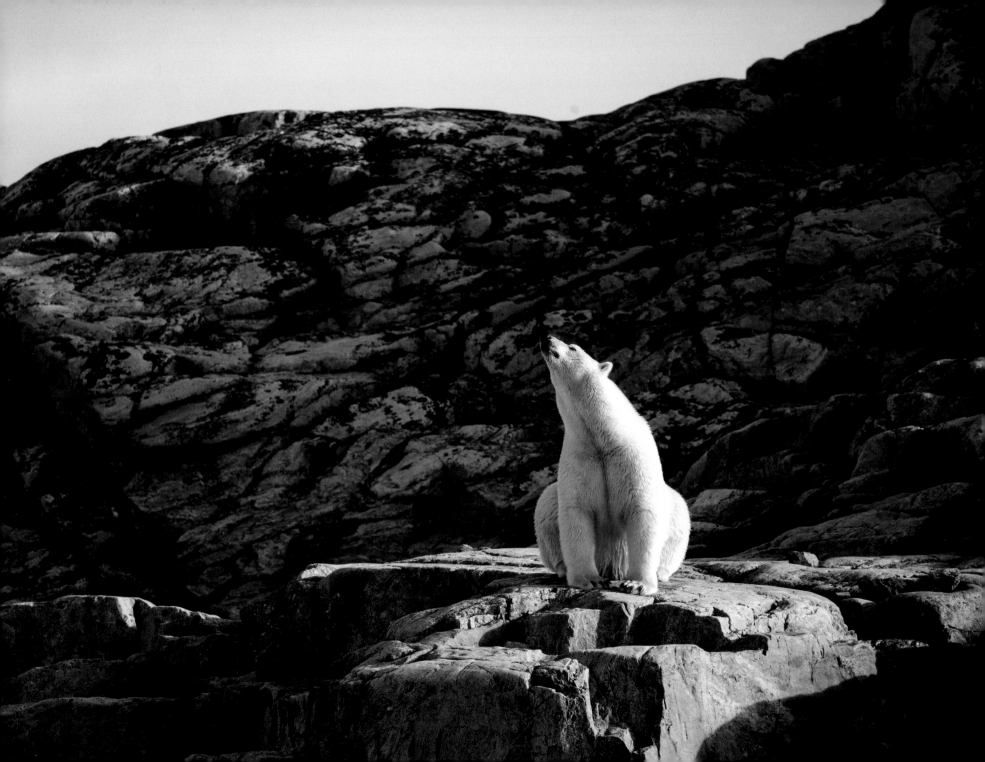

Ever since I can remember, I knew about people hunting. When I was a teenager, my father took me polar bear hunting with dog teams . . . We travelled far from our camps to go polar bear hunting. My father didn't always have a successful polar bear hunt, but he would have success from time to time. There was a saying, too, that said, "Don't ever want to have polar bears arrive, because polar bears know. If we say we want the polar bears to arrive, they might come and terrify us." I have heard that from my father. He also said that we should never mistreat animals or make fun of them, and that we should never wish for polar bears to arrive in our camps—such as saying, "I want the polar bears to arrive so I can catch one"—because the bears know and might come and terrify people. We should never talk badly about polar bears. No one should say that polar bears are not scary, or anything like that. That goes for all the animals, but from what I have heard, polar bears have been the scariest animal.

—*Daniel Qattalik, Igloolik*

A caribou came slowly down wind, grazing as it went, when it met a bear. When they met, they spoke to each other in this way. The caribou was the first to speak, and it said, "Let us try pulling arms."

The bear looked at it a little, and then said, "Oh, I am afraid I shall break your upper arm."

The caribou answered, "I can use it without fear of breaking it. Let us try."

The bear looked once more at the other's forelegs, and then said, "No, we had better not. I am afraid of breaking it."

The caribou answered, "I often gallop, and I am never afraid of breaking my forelegs."

So they began pulling arms. At first they did as men do when pulling arms, to show their confidence and give their opponent a chance. They each stretched out an arm now and again toward the other. But at last the bear dared not do so anymore, and kept his arm in the same position all the time. Then the caribou began to pull, and very slowly, straightened out the bear's foreleg with such force that it tore the skin and flesh from the whole of the upper arm and broke the bone.

Wild with pain and shame, the bear bit at its opponent, but the caribou had already made a great leap and was gone.

—Ivaluardjuk, traditional story recorded in the Igloolik area, 1920s

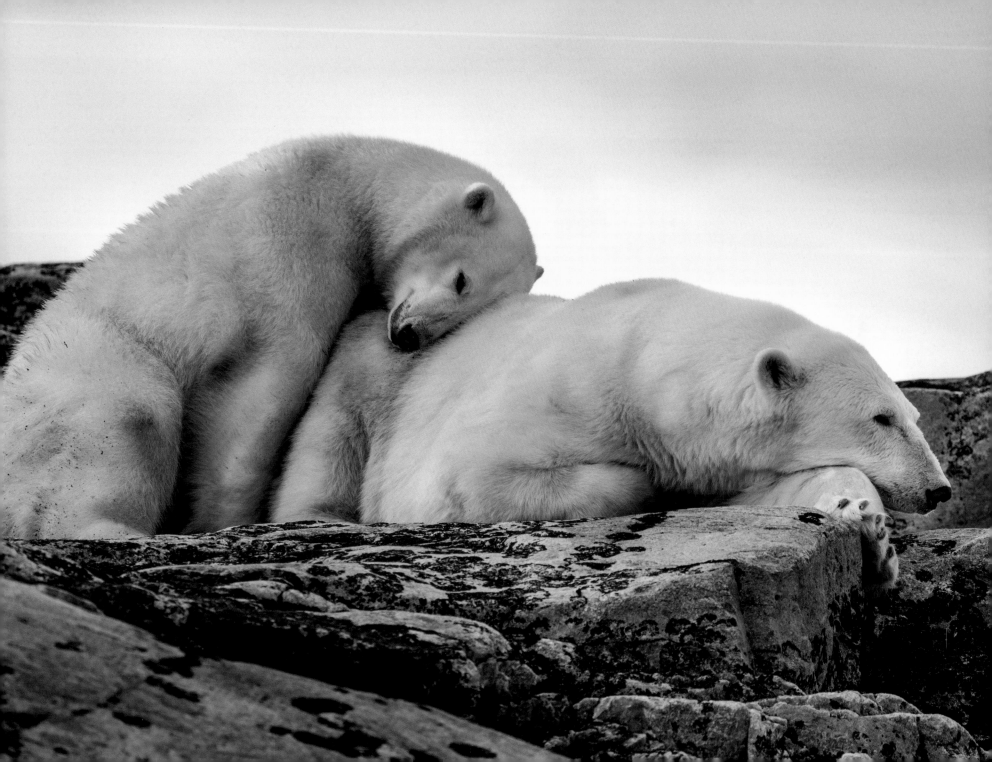

There was once an old woman who took in a bear's cub to live with her. She brought it up and taught it, and soon it was big enough to go out and play with the children in the village. The bear and the children fought and wrestled and played together.

The bear grew up and was soon so big that some of the people in the village wanted to kill and eat it. But the old woman wept and prayed for her bear. She so wished that it might live. When at last she dared not keep it any longer, she urged it to run away. But before the bear left its foster mother, it spoke to her, saying:

"You shall never suffer want. If you should be in want, go down to the edge of the ice, and there you will see some bears. Call them, and they will come."

The old woman did as the bear had said. When she began to be in want, she went out onto the sea ice and began looking about for bears. She saw a bear on a drifting ice floe and called to it, but when the bear saw and heard her it fled away.

The old woman went on until she saw another bear, and called to this one also. The bear heard her, and as soon as it had seen her, it ran over to the other bear that was close by and began fighting with it. It soon killed the bear it was fighting, and hauled it in to land, and left it there even before the foster mother had reached the spot. After that the old woman lived in abundance on the meat of the bear that had been given to her, and even gave her neighbours some for themselves. Thus it came about that greedy people in the village themselves caused a bear that might have procured meat for them all to go away and leave them.

—*Inugpasugjuk, traditional story recorded in the Igloolik area, 1920s*

White Island, Nunavut

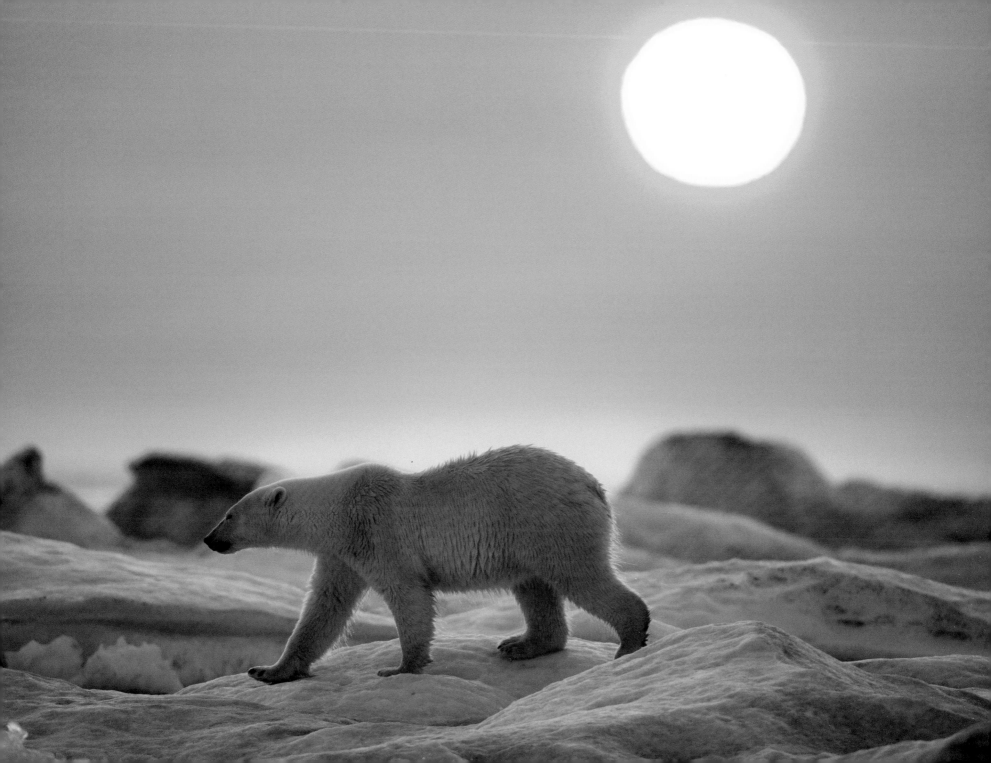

I wasn't sure how I was going to sleep. We had been observing and filming polar bears just steps from this cabin all week. And when I say cabin, I really mean an insulated shipping crate. We were filming a safety video and needed to film interactions between people and bears to illustrate how to behave sensibly around bears. It was myself, the cameraman, and the bear dog—a dog that doesn't fear bears and will chase them away—jammed into the tiny cabin. Lights finally out, we all lay there silent and unable to sleep.

After what felt like an eternity, I must have fallen asleep because I was startled awake by the sounds of footsteps outside. It was pitch black and instantly I knew that the only creature that would be wandering around outside of our cabin would be one of the numerous bears that were in the vicinity. The steps were slow and deliberate— and sounded like a very heavy person walking across Styrofoam—the characteristic crunch of dry, compacted, High Arctic snow. I followed the sounds of the steps as the bear walked around the entire cabin. The bear was walking so slowly and so carefully that part of me wanted to yell out, "You know I can hear you, right?" I thought about the "door," which was a half-inch piece of plywood closed with a string that was looped over a nail. Not much resistance for a bear interested in gaining access. What got me out of my sleeping bag and grabbing my shotgun was when the bear paused, stood up on its hind feet and gave the whole cabin a strong push. I heard the bear exhale as it dropped back onto all four feet.

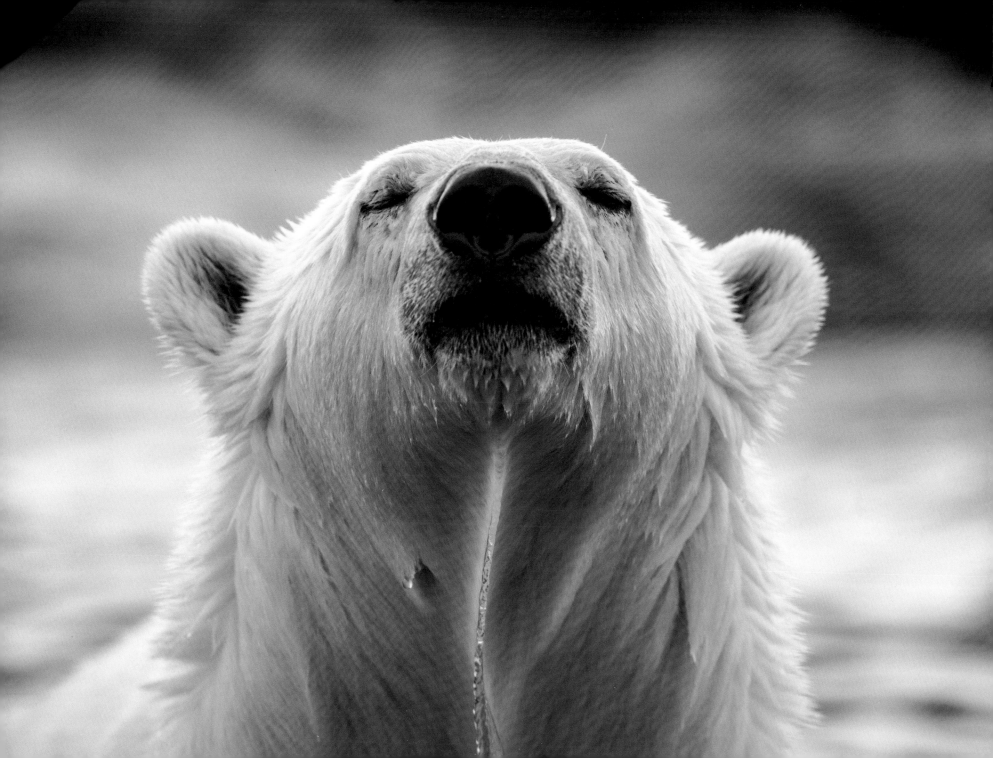

The camera guy was almost awake and likely didn't understand quite what was happening. Our fearless bear dog knew exactly what was happening and, looking terrified, basically cowered under the mattress bench. There was an eighteen-inch square Plexiglas window in the cabin. Grabbing my gun and a flashlight, I tiptoed over to it and looked out. Blackness. I grabbed for my pen light and brought it up to the window. It took me a while to find the switch, and, taking a deep breath, I turned it on. It took a second for my eyes to adjust to the light, and when they did I came nose to nose with that polar bear. It, too, had wanted to look through the window at the exact same instant—and there we were. Maybe it was only a second or two for the both of us to react, but it felt much longer. I think I may have seen the bear's pupils dilate when the light went on. Both the bear and I fell backwards immediately. I am not sure which of us was more scared. Once I regained my senses, I shined the light out through the window again and caught sight of the bear sprinting off toward the sea ice. I looked over at the bear dog, standing there proud as ever and looking courageous. "You're welcome," I said.

—Tony Romito, Resolute Bay

Repulse Bay, Nunavut

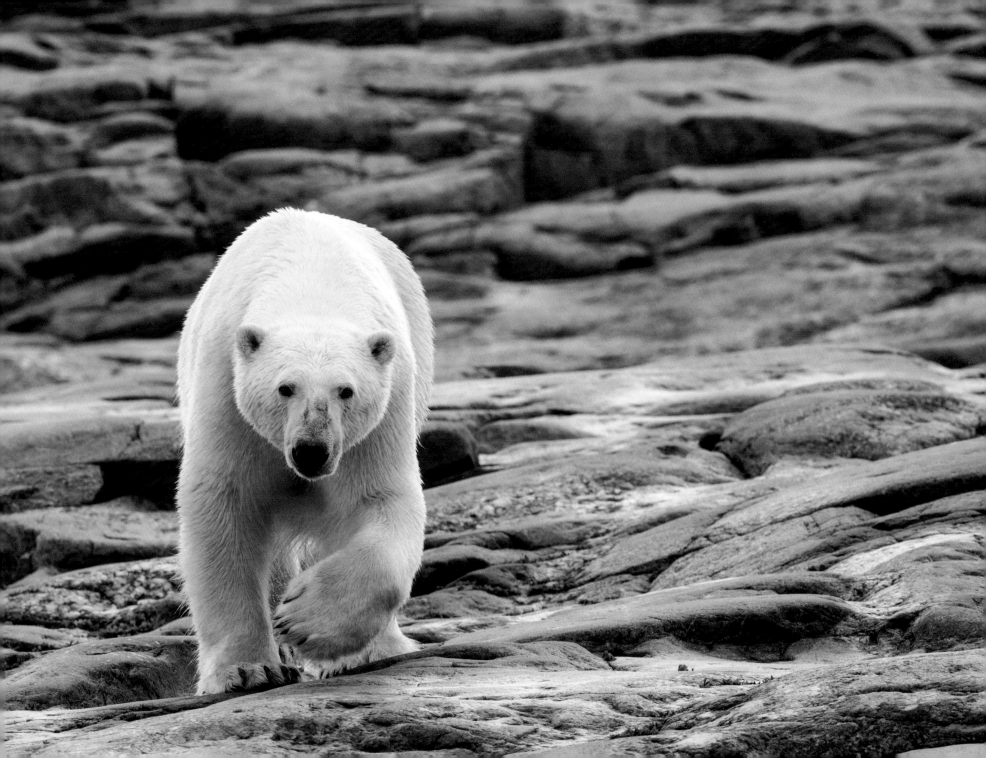

There was a time when we were at our caribou hunting camp. I was alone in the tent while my husband was out hunting. I heard dogs fighting behind the tent. One of the ropes to keep the tent up had been taken out from the fight, so when it sounded like there was no more fight going on, I went out and fixed it during the night. I didn't bother to look around. The next morning, I went to see my friend and told her that I went outside during the night. She yelled at me, saying I shouldn't be outside alone during the night and asked me why I was outside. I told her that two dogs were fighting right outside the tent. She told me that the dog was fighting a polar bear. I didn't realize it was a polar bear until I told my friend what I had heard.

—Peepeelee Kunilusie, Pangnirtung

Svalbard, Norway

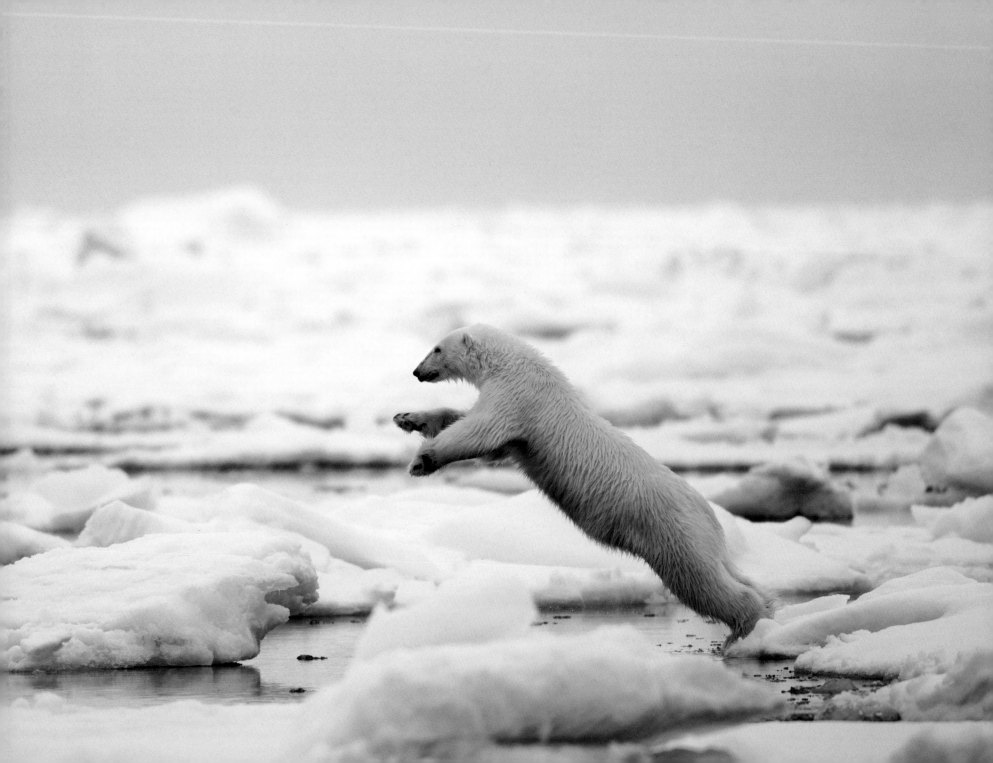

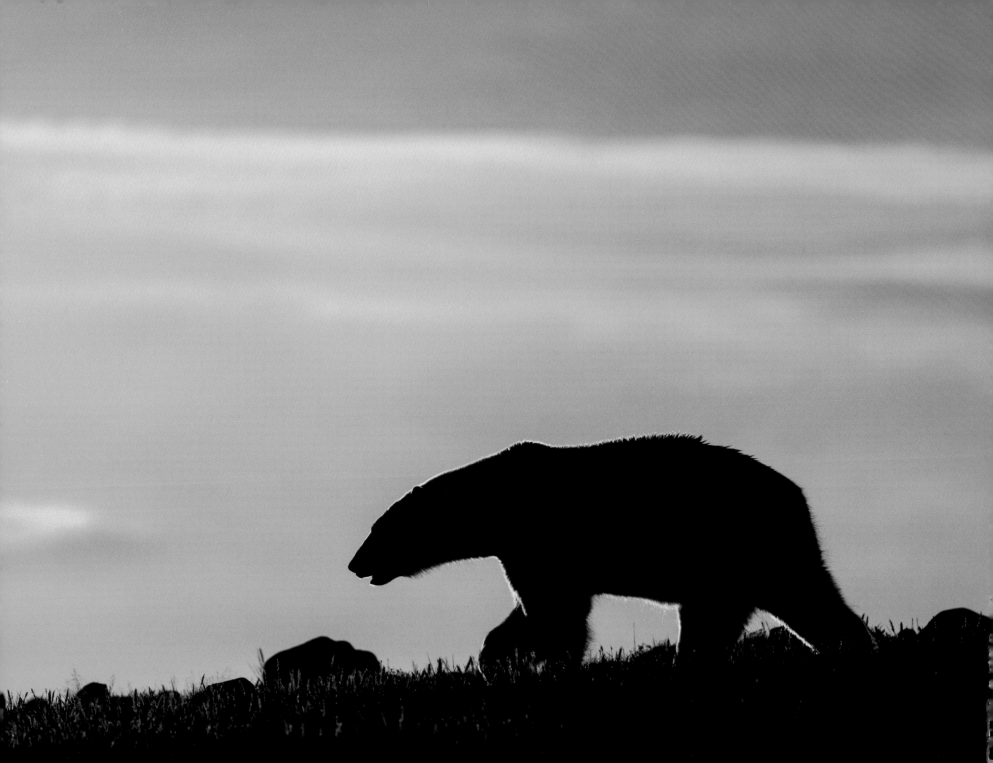

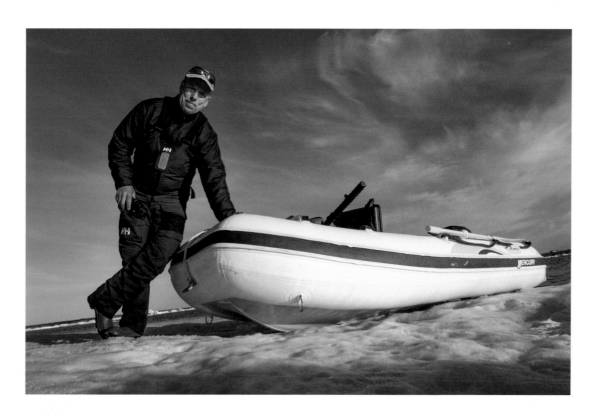

PAUL SOUDERS

Paul Souders is a professional photographer, travelling around the world and across all seven continents for more than thirty years. His images have appeared around the globe in a wide variety of publications, including *National Geographic*, *Geo* in France and Germany, *Time* and *Life* magazines, as well as hundreds of publishing and advertising projects. His recent photography work in the Arctic has drawn wide acclaim, including first place awards at the BBC Wildlife Photographer of the Year competition in 2011 and 2013, the *National Geographic* Photo of the Year contest in 2013, and Grand Prize in the 2014 Big Picture Competition. Over the last three decades he has visited more than sixty-five countries and has been slapped by penguins, head-butted by walruses, terrorized by lions, and menaced by vertebrates large and small.

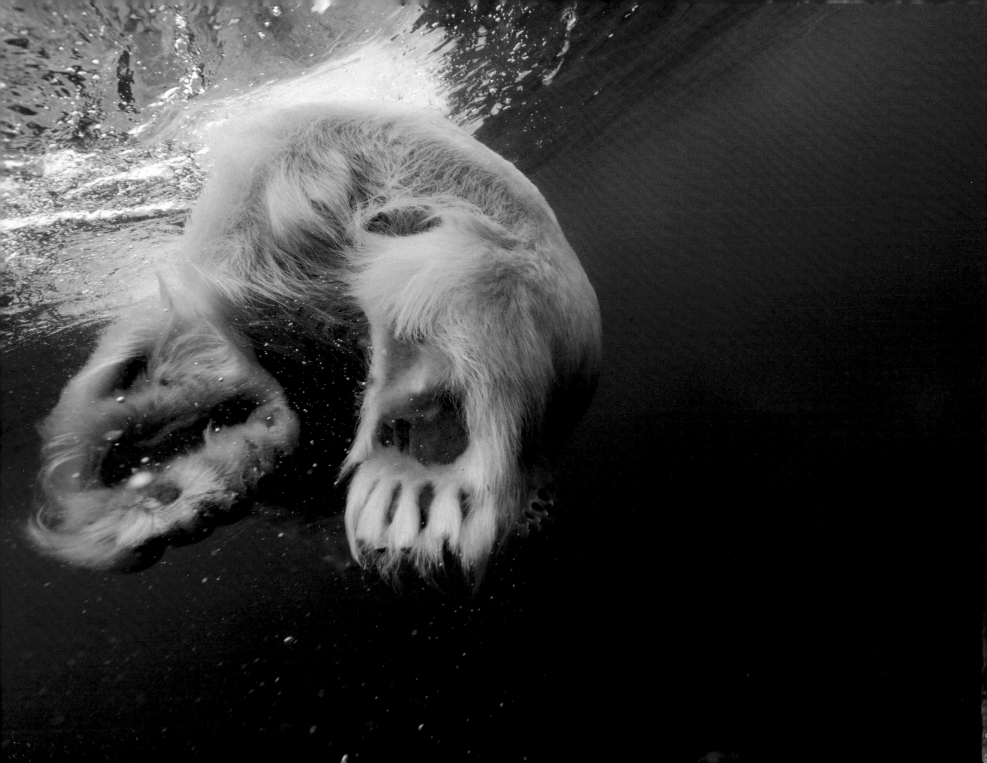